Let's Draw MANGA

ASTRO BOY

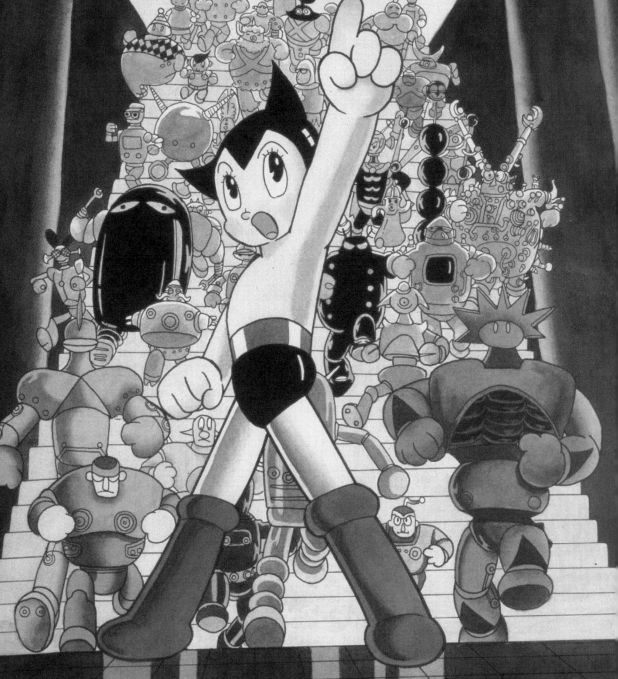

Special Thanks to
Executive Producer: MR. MINORU KOTOKU

Illustration & Compostion:	**JUNJI KOBAYASHI**
Production Supervisor:	**KEN SASAHARA**
Translation:	**FAIZI PARKES**
English Editing:	**THE EAST PUBLICATIONS, INC.**
Layout:	**GEN ISHO, INC.**
Editing Assistant:	**TRISHA KUNIMOTO**
Publisher:	**HIKARU SASAHARA**
Japan Relations:	**JOHN WHALEN**
Print Production Manager	**FRED LUI**

LET'S DRAW MANGA
Astro Boy

English Edition Published by
DIGITAL MANGA PUBLISHING
1123 Dominguez Street, Unit K
Carson, CA 90746
www.emanga.com
tel: (310) 604-9701
fax: (310) 604-1134

Distributed Exclusively in North America by
WATSON-GUPTILL PUBLICATIONS
a division of VNU Business Media
770 Broadway, New York, NY 10003
www.watsonguptill.com

ISBN: 1-56970-992-0
Library of Congress Control Number: 2003095715
First Edition January 2004
10 9 8 7 6 5 4 3 2 1

Printed in China

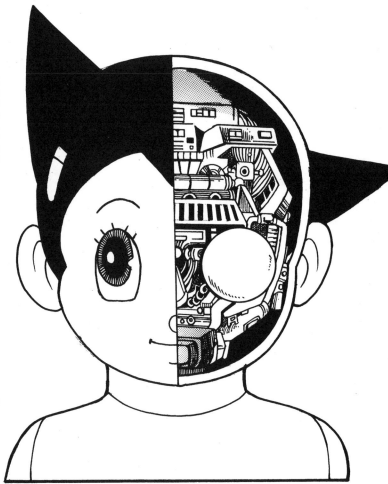

ASTRO BOY

By Tezuka Productions:
Junji Kobayashi

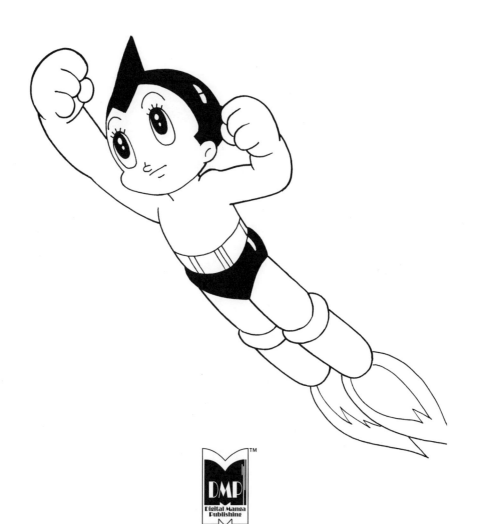

DIGITAL MANGA PUBLISHING

Carson

CONTENTS

Introducing Astro Boy

Astro Boy is a renowned super hero through-
out the world. Emerging midway through the
20th century, in 1951, he was Osamu
Tezuka's creation par excellence. Since his
birth half a century ago, Astro Boy has
endured as a national hero and a popular
character in Japan. This lengthy history is
second only to Mickey Mouse, the creation of
Walt Disney, who Osamu Tezuka revered.
With his big round eyes, button nose, and
angular hairstyle, Astro Boy can be drawn by
nearly anyone. Although the design is simple,
drawing Astro Boy with facial expressions
and in poses is surprisingly difficult, even for
the animators at PLEX. Osamu Tezuka made
the circle the core of his character design.
Combinations of small and large circles are
what make Astro Boy and Leo especially
adorable. This lavishly illustrated book pro-
vides easy-to-understand explanations on
how to draw Astro Boy.

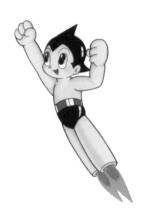

History of Astro Boy

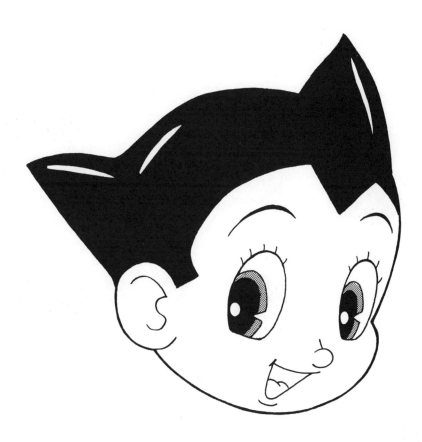

History of Astro Boy ●●●●●●●●●●●●●●●●●●●●●●●●●●●●●●●

Astro Boy was the hero of a magazine comic strip from 1951 through 1968. During those 18 years, his physical appearance changed markedly, as illustrated below.

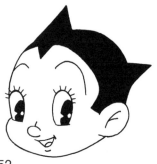

1952
In "Frankenstein" he has a round face and seven eyelashes.

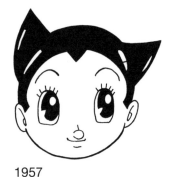

1957
In "Plankton Eroth Family," the many highlights produce a mechanical look.

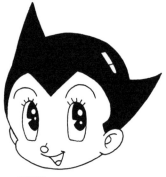

1968
In "The Man Who Returned From Mars," he has large pointy locks of hair.

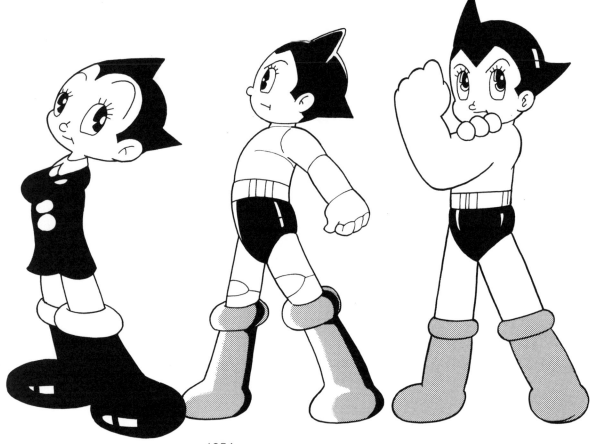

1952
The free-flowing form is reminiscent of early manga characters.

1954
He is shown with arm and knee joints in only a few drawings.

1967
Astro Boy came to have a powerful appearance. The comic strip ended in the following year.

Astro Boy's Evolution

Early period (1951–1956)

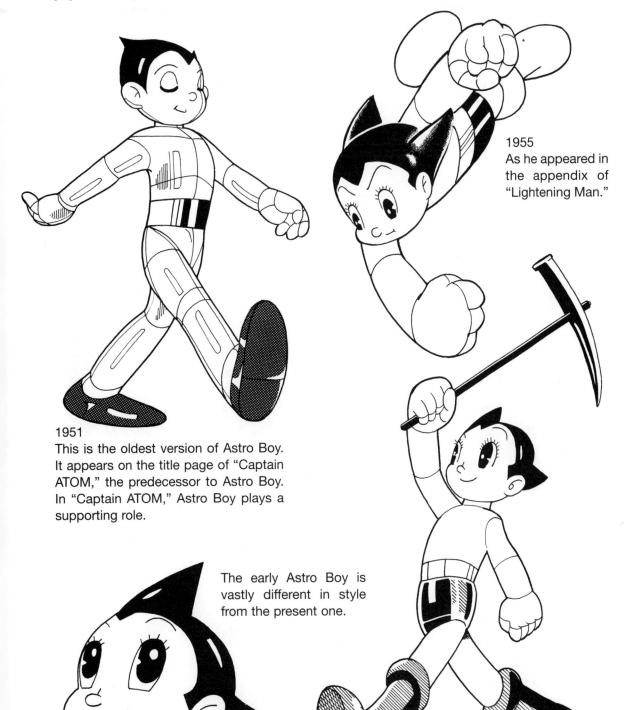

1955
As he appeared in the appendix of "Lightening Man."

1951
This is the oldest version of Astro Boy. It appears on the title page of "Captain ATOM," the predecessor to Astro Boy. In "Captain ATOM," Astro Boy plays a supporting role.

The early Astro Boy is vastly different in style from the present one.

1958
Astro Boy's hair was drawn with a soft look.

1956
The cover of a book. The design is midway between the old Astro Boy and the current one.

Astro Boy's Evolution ●●●●●●●●●●●●●●●●● *Part* 2

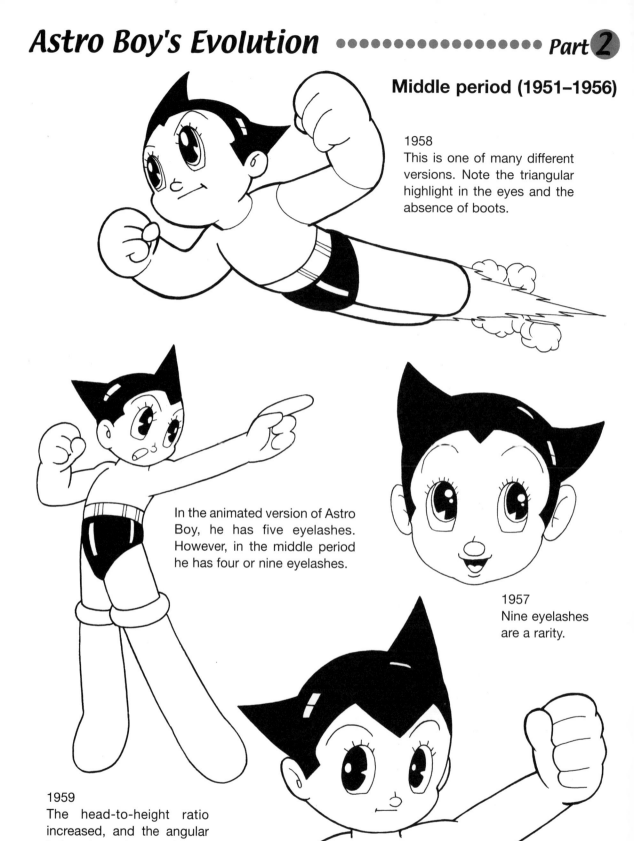

Middle period (1951–1956)

1958
This is one of many different versions. Note the triangular highlight in the eyes and the absence of boots.

In the animated version of Astro Boy, he has five eyelashes. However, in the middle period he has four or nine eyelashes.

1957
Nine eyelashes are a rarity.

1959
The head-to-height ratio increased, and the angular hair and eyes became larger.

1961 Here he resembles the character in the black-and-white animated television series.

Astro Boy's Evolution

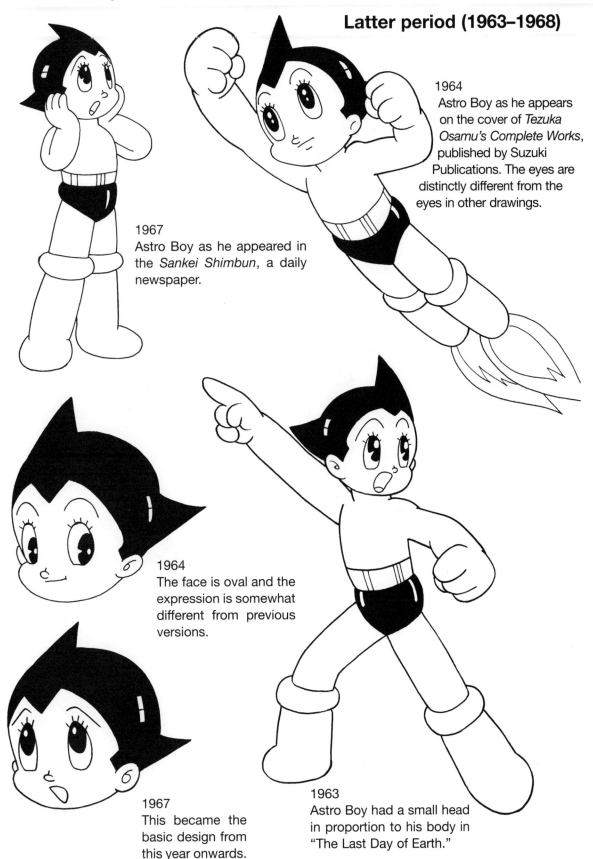

Latter period (1963–1968)

1964
Astro Boy as he appears on the cover of *Tezuka Osamu's Complete Works*, published by Suzuki Publications. The eyes are distinctly different from the eyes in other drawings.

1967
Astro Boy as he appeared in the *Sankei Shimbun*, a daily newspaper.

1964
The face is oval and the expression is somewhat different from previous versions.

1967
This became the basic design from this year onwards.

1963
Astro Boy had a small head in proportion to his body in "The Last Day of Earth."

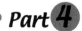
Astro Boy after the series ended.

After the end of the *Astro Boy* television series in 1968, Astro Boy made occasional appearances in children's programs and magazines. On each occasion—from the cover of the complete works to the 1980 television series—he had a slightly different look.

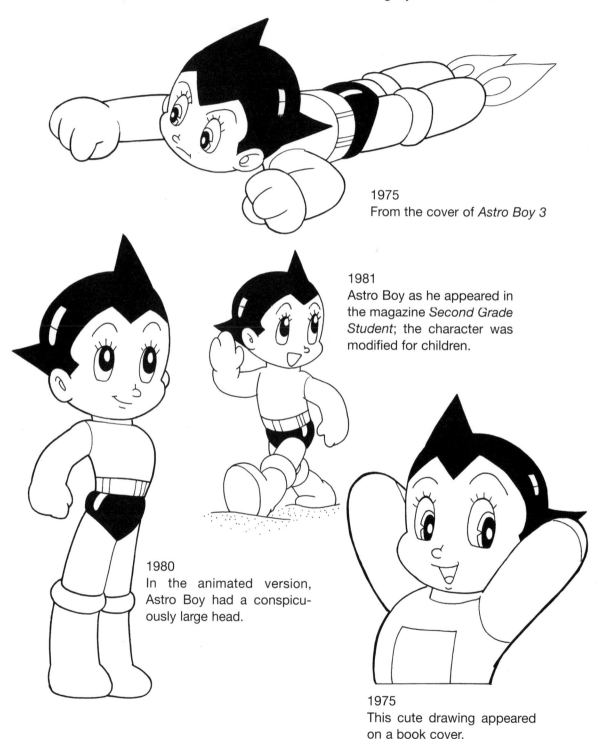

1975
From the cover of *Astro Boy 3*

1981
Astro Boy as he appeared in the magazine *Second Grade Student*; the character was modified for children.

1980
In the animated version, Astro Boy had a conspicuously large head.

1975
This cute drawing appeared on a book cover.

Different examples of Astro Boy •••••••••••••●

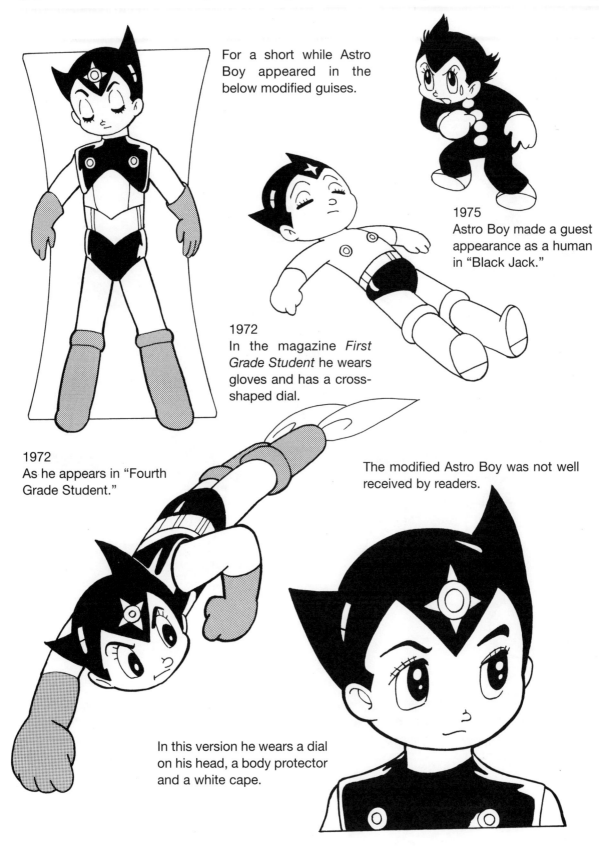

For a short while Astro Boy appeared in the below modified guises.

1975
Astro Boy made a guest appearance as a human in "Black Jack."

1972
In the magazine *First Grade Student* he wears gloves and has a cross-shaped dial.

1972
As he appears in "Fourth Grade Student."

The modified Astro Boy was not well received by readers.

In this version he wears a dial on his head, a body protector and a white cape.

Different head-to height ratios

Astro Boy's head-to-height ratio has shown wide variation over the years. In adapting him for children, Tezuka allowed Astro Boy to grow for three years before reducing his size and starting over.

A head-to-height ratio of 1 to 5

A head-to-height ratio of 1 to 3.6

A head-to-height ratio of 1 to 3

A head-to-height ratio of 1 to 3.8

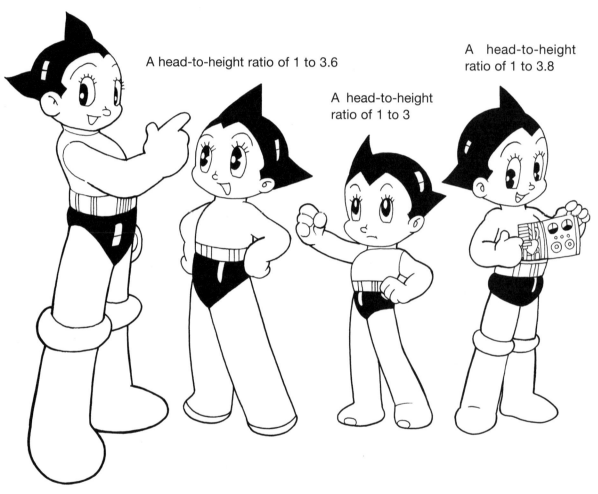

1957	1960	1980	1964
In 1957–58, Astro Boy's head was the smallest ever in proportion to his body.	He later grew shorter and chubbier, but remained cute.	In the prototype for a television series, his head was the largest ever in proportion to his body.	The average head-to-height ratio was also popular with the public.

Astro Boy today-the 2003 animated television program

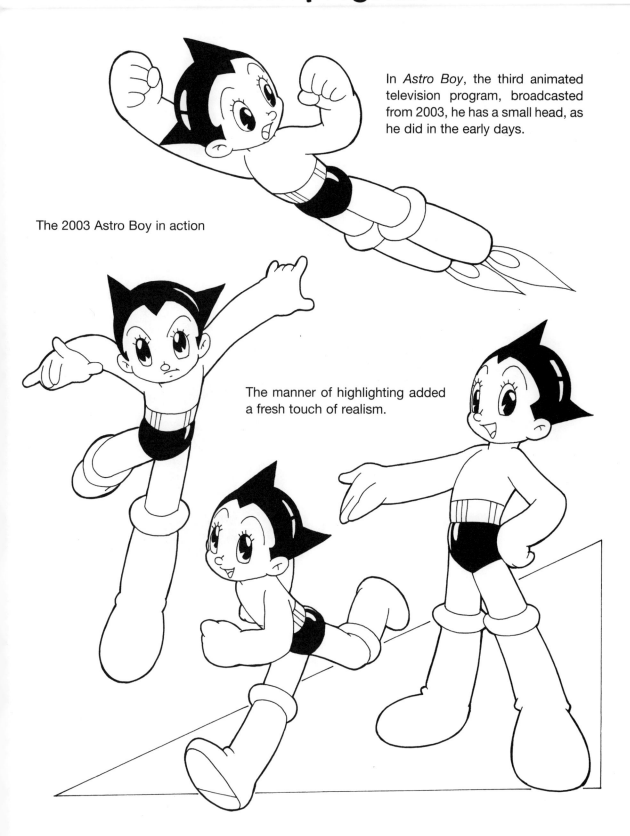

In *Astro Boy*, the third animated television program, broadcasted from 2003, he has a small head, as he did in the early days.

The 2003 Astro Boy in action

The manner of highlighting added a fresh touch of realism.

Let's Draw Astro Boy!

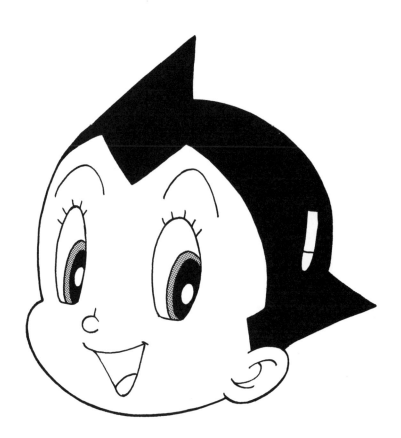

Design characteristics of Tezuka's manga ●●●●● ●

Use of circles—Part 1

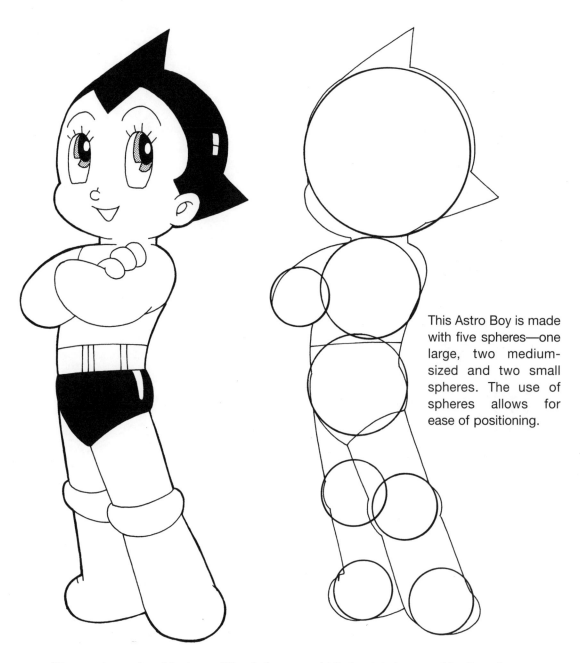

This Astro Boy is made with five spheres—one large, two medium-sized and two small spheres. The use of spheres allows for ease of positioning.

The most prominent feature of Tezuka's manga is their origin in a combination of circles. Few circles are used for a character with a large head in proportion to the body, and many for one with a small head. But whatever the head-to-body ratio, all of his manga originate in a combination of circles. Tezuka's original techniques include dynamic representation of movement in an action scene and highlight that expresses the twinkle in the eyes and direction they are looking.

Design characteristics of Tezuka's manga ●●●●●●

Use of circles—Part 2

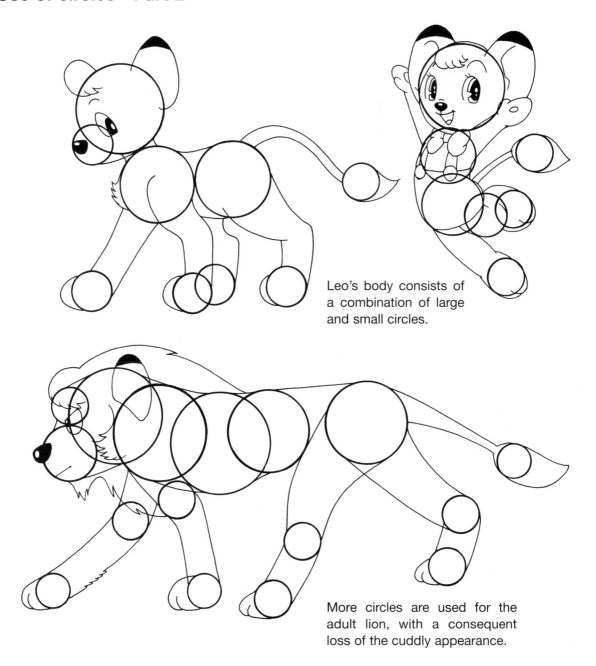

Leo's body consists of a combination of large and small circles.

More circles are used for the adult lion, with a consequent loss of the cuddly appearance.

Expressing cuteness in Tezuka manga

Many of Tezuka's main characters are animals. In *Jungle Emperor Leo*, one of his greatest works, the central character, Leo, is made from circles. This technique was borrowed from Disney, whose characters required smooth movement and a three-dimensional look for animation. By chance, this technique also created adorable-looking characters.

Design characteristics of Tezuka's manga ●●●●●

Manga-like exaggeration

Tezuka developed and often used the technique of deformation, which smoothly integrates a character in an action scene.

Drawing Astro Boy in parallell with "flow lines" emphasizes the sense of motion.

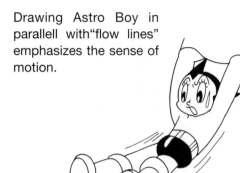

An extreme example of deformation

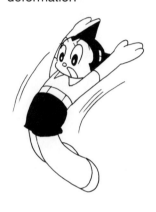

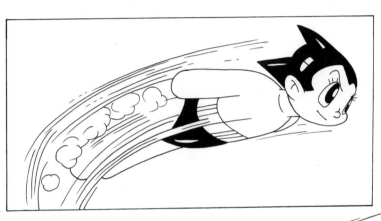

Astro Boy hurtles through the sky in a stream of curved lives. Tezuka did not use this design method in his early works, but here he employs it to effect.

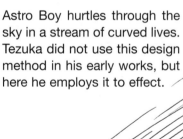

Drawing curved motion lines suggests movement.

Design characteristics of Tezuka's manga •••••

Cinematic style

When Tezuka debuted with "New Treasure Island" in 1946, readers were amazed by the cinematic look they were seeing for the first time. The cartoonist employed various cinematic devices in the *Astro Boy* manga.

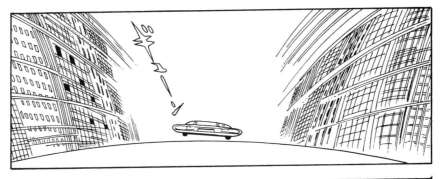

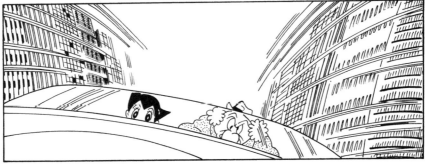

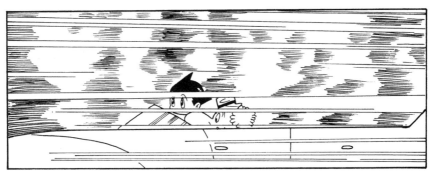

A stationary camera records the approach of Astro Boy and Dr. Ochanomizu as they drive down a city street. Drawing the buildings as if they're flying past increases the sense of speed. In the third frame, the camera shoots the scene from the side and the buildings appear as a blur. This is Tezuka at his best.

Astro Boy is drawn as if being looked down upon from the upper left.

Seen from the front

From the 2003 *Astro Boy* television series

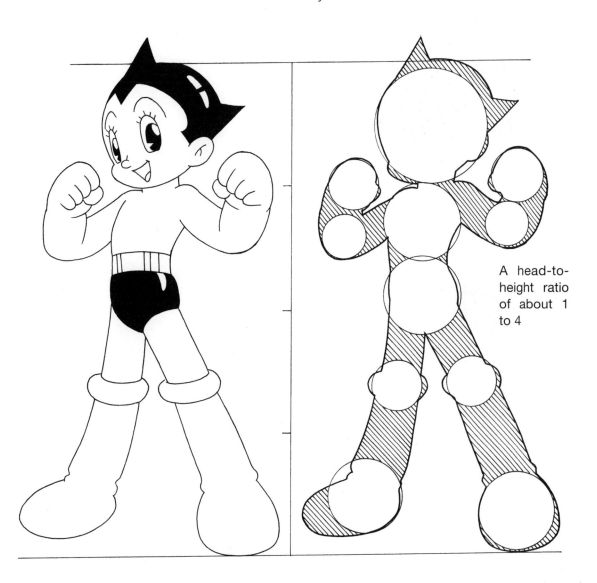

A head-to-height ratio of about 1 to 4

From the black-and-white version of 1963–1966, followed by the 1980 colored version to the latest adaptation, Astro Boy's shadowing, highlights, details and emotions have become increasingly realistic. The boots, for example, now have wrinkles to show the fit.

Astro Boy's proportions

Seen from the side

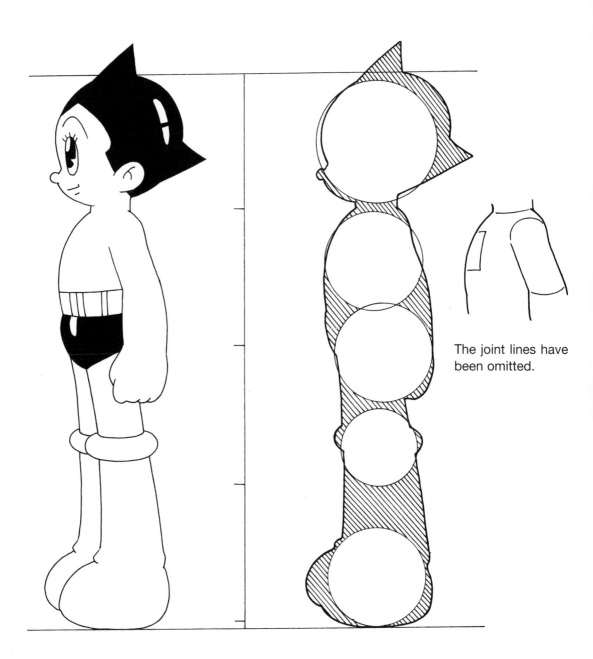

The joint lines have been omitted.

Even if he appears more real, Astro Boy's main feature remains in his manga-like look. His bodylines are built around spheres and most of the lines are curved. The shoulders, for example, slope considerably. The lines for the joints and chest hatch in the 1980 model have disappeared.

Astro Boy's proportions •••••••••••••••• *Part* 3

Seen from the rear

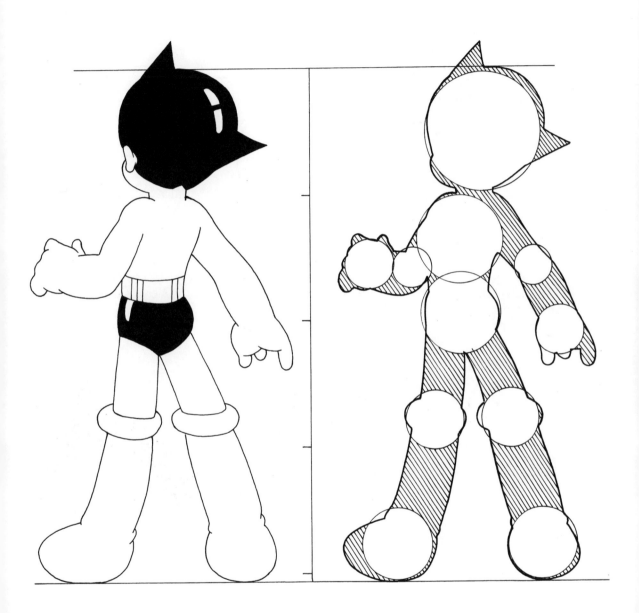

The highlights in the head and pants are used to add an accent rather than reflect light. The arms grow bigger and rounder in proportion to the distance from the body. Amplifying the bulge in the boots produces a sharp silhouette.

Drawing Astro Boy's face ●●●●●●●●●●●●● Part ❶

From the front

Drawing Astro Boy's face from the front is no easy task. If the scene does not require a frontal shot, then it's best to draw the face from a slight angle. You can draw the two locks pointing either to the right or left, as Tezuka did.

Not just Astro Boy, but all of Osamu Tezuka's adorable characters begin life as a circle.

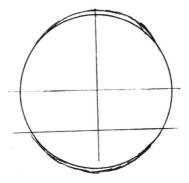

Astro Boy's face is not a perfect circle; so the top and bottom need to be slightly elongated. Draw a line to position the eyes.

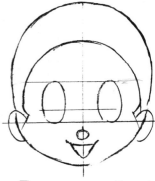

The eyes are positioned slightly below the center. A child's eyes are drawn below the center line.

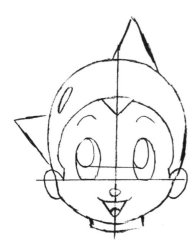

Using the cross drawn on the face as a guide, give Astro Boy a facial expression by drawing the eyes, nose, mouth and hair.

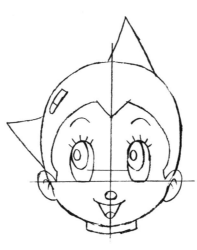

Give the eyes five lashes, add the highlight to the head and details to the ears, and complete the other facial elements. This completes the rough outline.

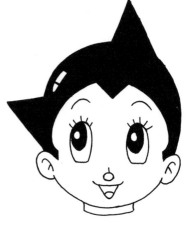

With a pen, draw over and hide the rough outline. Complete by applying black ink to the head.

How not to draw Astro Boy ●●●●●●●●●●●●●●●●●●●●●

If you give priority to the expression of emotion or try to draw according to theory, you will tend to create drawings like those below. Neither looks like Astro Boy.

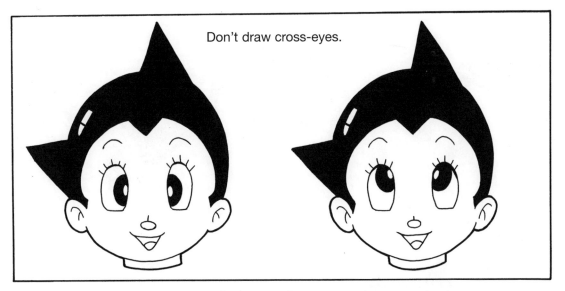

Don't draw cross-eyes.

Don't draw Astro Boy or any other Tezuka character with cross-eyes.

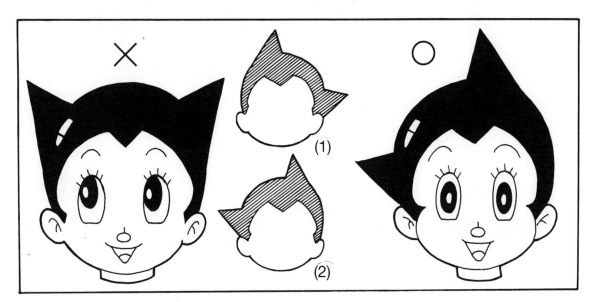

You may draw the pointy locks on the left or right side, but never symmetrically.

No.1 or No.2 is okay.

Large side burns that seem to cut into the head produce a bizarre monkey-like face.

Astro Boy's face in different frontal poses ●●●●● ●

As was mentioned earlier, Astro Boy's face changed over the years. Below is a random selection of full faces. There are few examples of Astro Boy's face drawn from the front. Most of these full faces are from book covers or frontispieces.

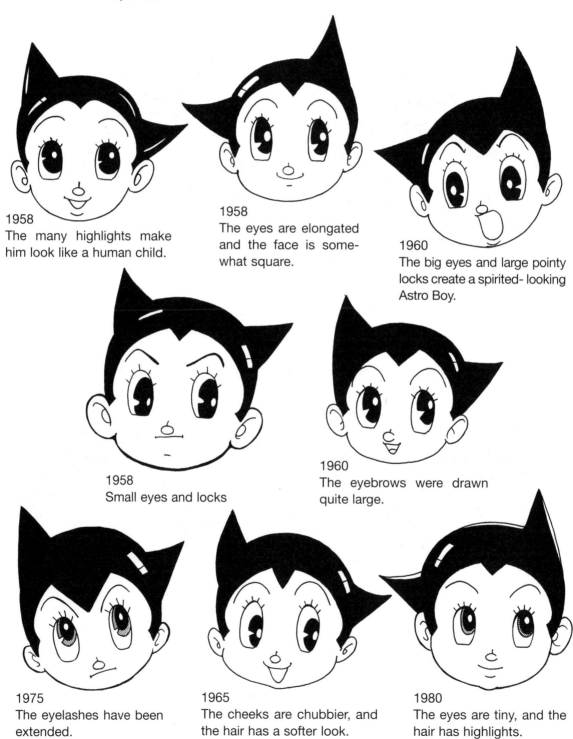

1958
The many highlights make him look like a human child.

1958
The eyes are elongated and the face is somewhat square.

1960
The big eyes and large pointy locks create a spirited- looking Astro Boy.

1958
Small eyes and locks

1960
The eyebrows were drawn quite large.

1975
The eyelashes have been extended.

1965
The cheeks are chubbier, and the hair has a softer look.

1980
The eyes are tiny, and the hair has highlights.

The profile

Astro Boy's manga-ish profile is one of his characteristics. For example, in profile, his mouth appears near his cheek. If he were drawn realistically, he would look totally different.

The side of the face also originates in a circle.

Increase the size of the back of the head and add the jaw portion.

The top of the jaw line will be where the nose sits. Draw the eyes and ears using the cross as a guide.

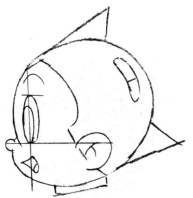

Draw the pointy locks and add the highlight in proper proportion to the head.

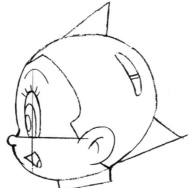

Draw the highlight in the eye and the eyelashes to complete the rough sketch. Next, thicken eye's outline beneath the lashes.

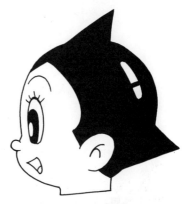

Now color in the eyes and the head with black ink. After the ink has dried, erase the sketch lines.

Drawing Astro Boy's face •••••••••••••• Part 3

Back of the head

On the rare occasion you need to draw the back of Astro Boy's head. You start by drawing a circle, as you would for any other view of the head.

The back of the head also originates with a circle.

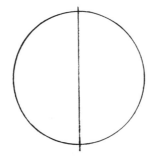

Draw a dividing line down the middle. This line will serve as a guide for drawing the neck, eyes and hair.

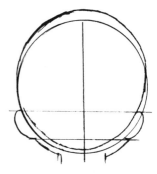

Astro Boy's head is not a perfect circle; so stretch the top and bottom. Next draw the ears.

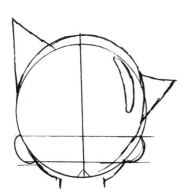

Draw the hair and add the highlight. Now the design is nearly complete.

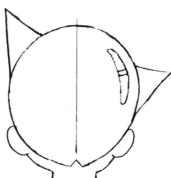

Tidy up the circle and draw a single line to guide the pen.

Now it's time to use the pen. You must ink in a substantial area. So take care not to leave any white spots and remember to erase the guidelines.

Drawing from an angle

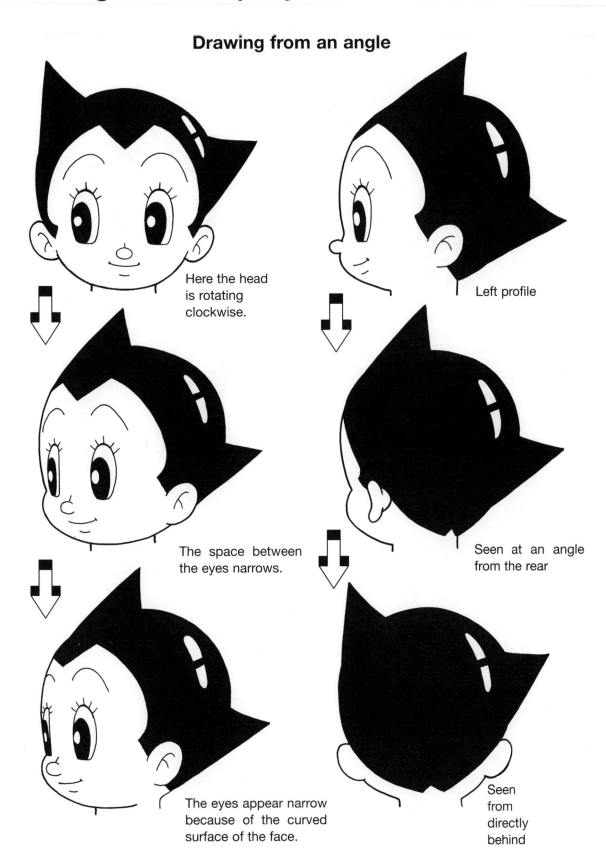

Here the head is rotating clockwise.

Left profile

The space between the eyes narrows.

Seen at an angle from the rear

The eyes appear narrow because of the curved surface of the face.

Seen from directly behind

Drawing the head at an angle ●●●●●●●●●●●● ●

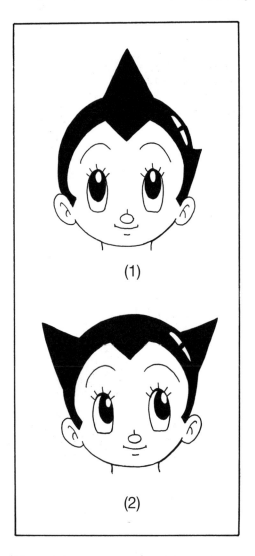

(1)

(2)

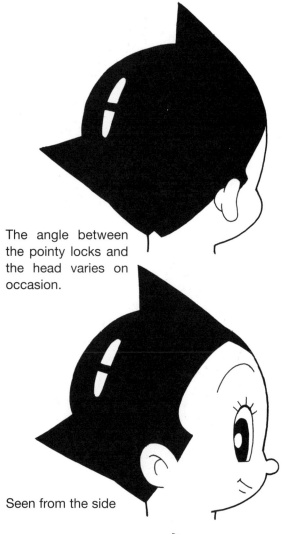

The angle between the pointy locks and the head varies on occasion.

Seen from the side

You might expect to be able to draw Astro Boy as in (1) and (2), but you should never depict the pointed locks as shown here. Illustration (1) totally changes the atmosphere of Astro Boy, which cannot even be used in animation.

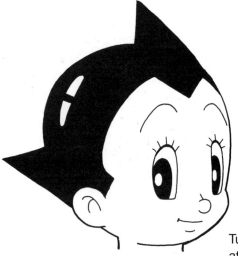

Turned to the right at an angle

When the eyes are drawn extremely small, they are solid black. Take care to reduce the size with skill.

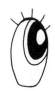

Astro Boy's eyes have changed over the years. None of these variations are mistakes. Use them creatively to effect.

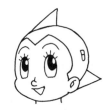

When the black eyes aren't particularly large, only highlight them. Draw the eyelids a little thicker.

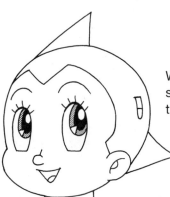

When you draw the eyes this size or larger, it is best to give them two pupils.

An extreme close up

When the eyes increase in size, the details should be enhanced. The eyebrows and eyelashes should be drawn thicker and the highlight within eye made larger.

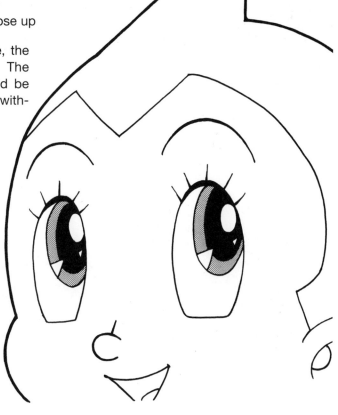

With an extreme close up, you would envisage the roots of the eyelashes being thicker and more highlight being required. However, if you proportionately increase the thickness of the eyelashes and size of the highlight, the drawing will lose its refinement.

Drawing the facial parts-the eyes, animated television program

•••• Part

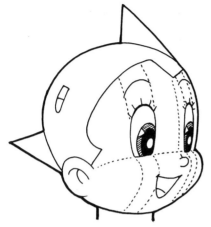

Drawing the eyes parallel with the curve of the face achieves a three-dimensional effect. Don't neglect to pay attention to the position and size of the mouth and nose.

This gaping mouth doesn't suit Astro Boy.

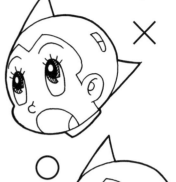

The open mouth would normally appear as in the left-hand drawing.

Eyelashes

Astro Boy usually has five eyelashes. All five are nearly always straight, although there are a few occasions when they curve. The below illustration shows the correct way to draw the lashes.

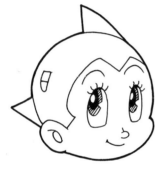

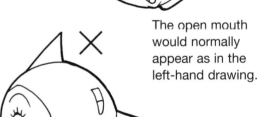

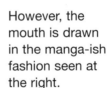

However, the mouth is drawn in the manga-ish fashion seen at the right.

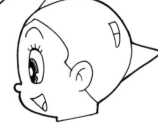

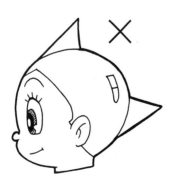

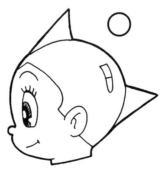

Sideburns

Thick sideburns are more suited for Astro Boy rather than the thin ones shown at the left.

Drawing the facial parts-the nose •••• Part 3

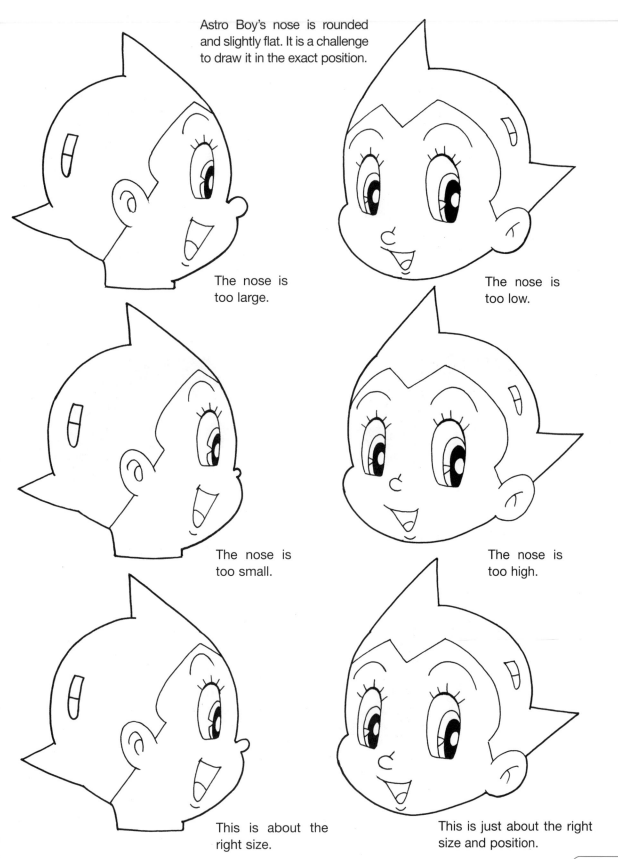

Astro Boy's nose is rounded and slightly flat. It is a challenge to draw it in the exact position.

The nose is too large.

The nose is too low.

The nose is too small.

The nose is too high.

This is about the right size.

This is just about the right size and position.

Drawing the facial parts-the hair •••• Part 4

Astro Boy has gone through many hairstyles over the years.

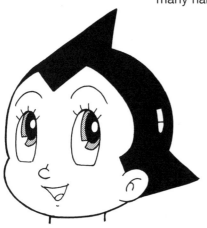

(1) Standard pointy locks

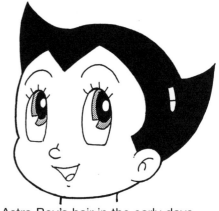

(4) Astro Boy's hair in the early days

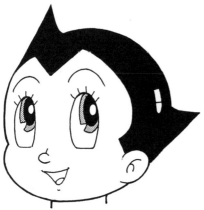

(2) Short pointy locks

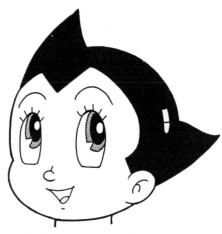

(5) Curvy pointy locks

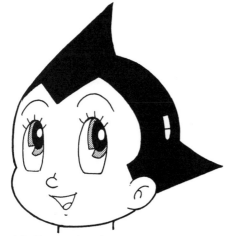

(3) The hair takes up a large portion of the head.

Astro Boy's pointy locks are unique, and their size and shape greatly influence his appearance. Illustrations (3), (4) and (5) are not mistakes, but rather show hair styles that have not been drawn in recent years. They are shown here for reference only.

Head shape

Arranging the characteristic pointy locks by 3D wire frame drawing

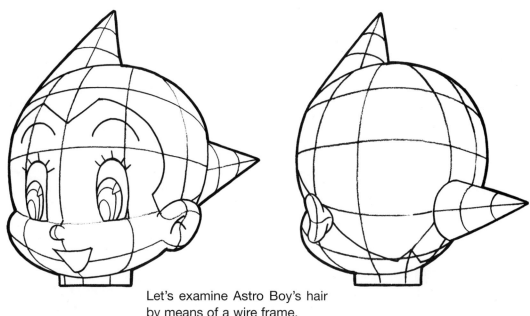

Let's examine Astro Boy's hair by means of a wire frame.

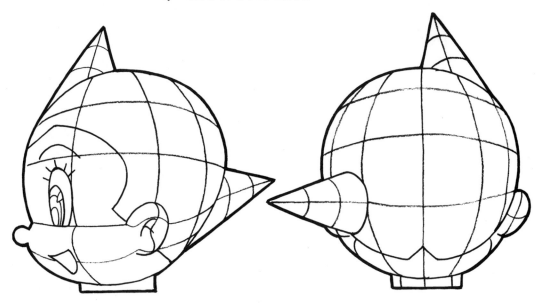

With this wire frame, you can see where the raised and indented areas lie and where the cheeks bulge. It is best to position the rear pointy lock slightly to the left or right from the center.

A 3D wire frame of Astro Boy's entire body

The curved lines give Astro Boy his characteristically soft appearance.

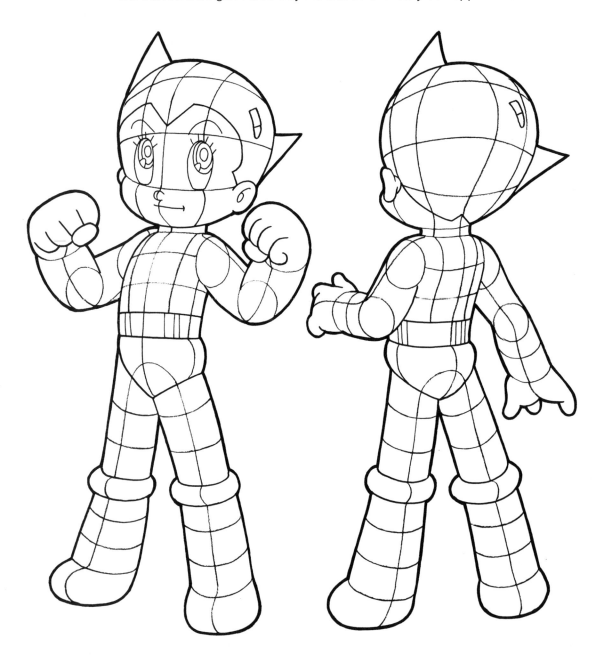

This is the manga version of Astro Boy. Note the raised and indented portions of the head, arms, shoulders, back, hips and legs. Not only Astro Boy, but nearly all of Tezuka's characters make use of these curved lines.

Facial expressions

Astro Boy is capable of expressing a variety of human emotions.

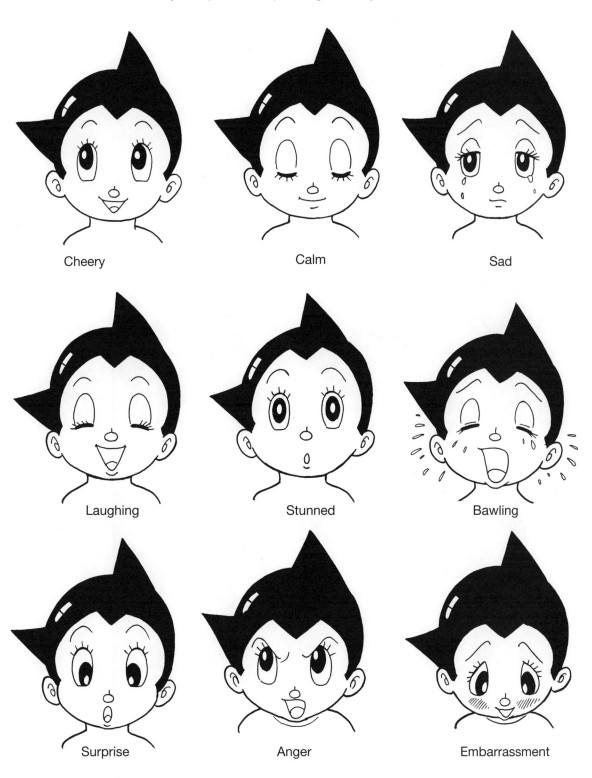

Cheery

Calm

Sad

Laughing

Stunned

Bawling

Surprise

Anger

Embarrassment

Different facial expressions- the old Astro Boy

From the cover of the complete works published by Kobunsha

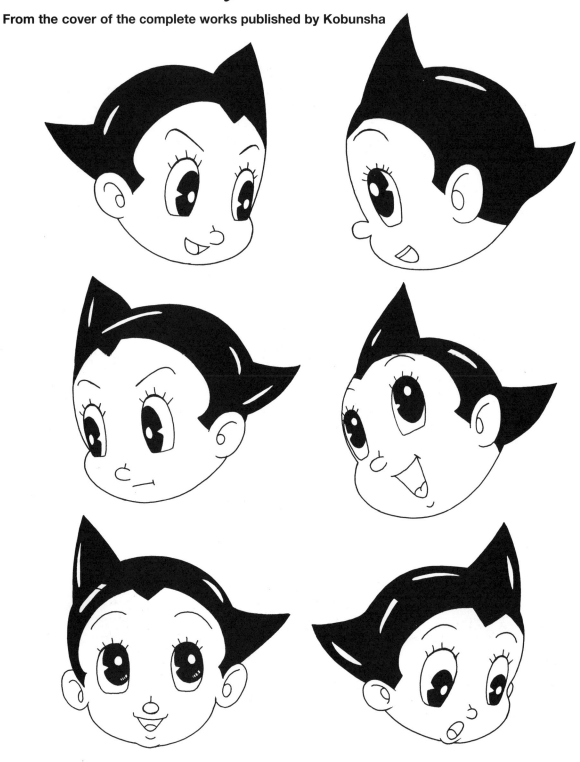

This is the old Astro Boy, who appeared in 1958-1960. The cute, wavy pointy locks and the heavy highlighting are typical of this period.

Different facial expressions - the old Astro Boy

Astro Boy's various expressions in different periods

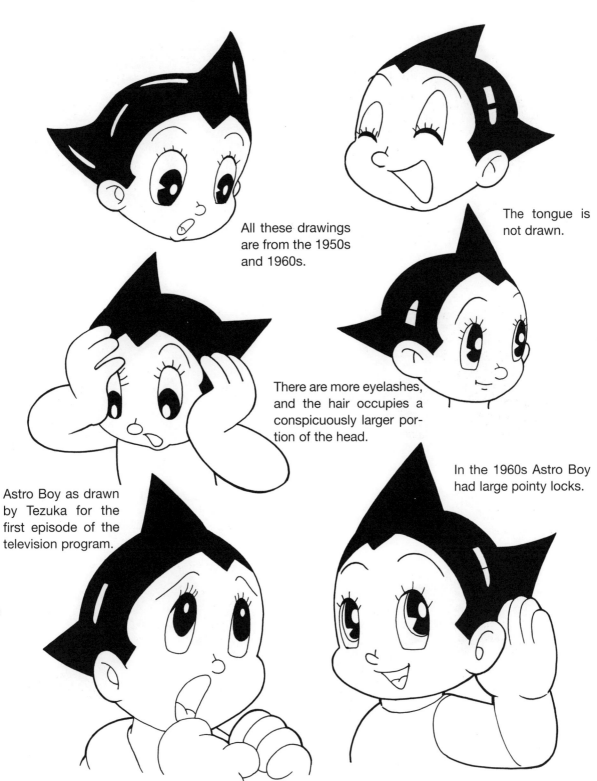

All these drawings are from the 1950s and 1960s.

The tongue is not drawn.

There are more eyelashes, and the hair occupies a conspicuously larger portion of the head.

In the 1960s Astro Boy had large pointy locks.

Astro Boy as drawn by Tezuka for the first episode of the television program.

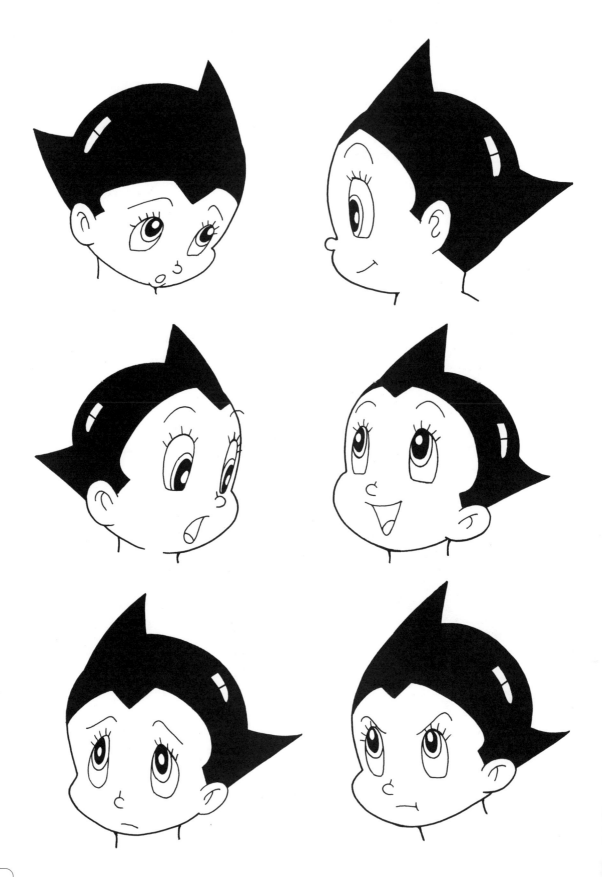

Different facial expressions ••• Part 2 black eyes

The facial expressions Tezuka designed for television in 1980

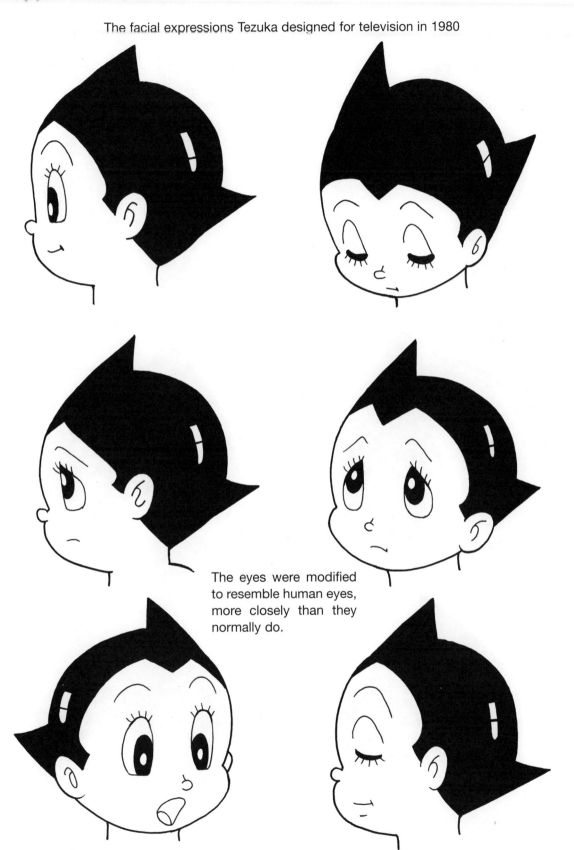

The eyes were modified to resemble human eyes, more closely than they normally do.

Different facial expressions ••• Part 3 black eyes

These faces were drawn for the 1980 television series.

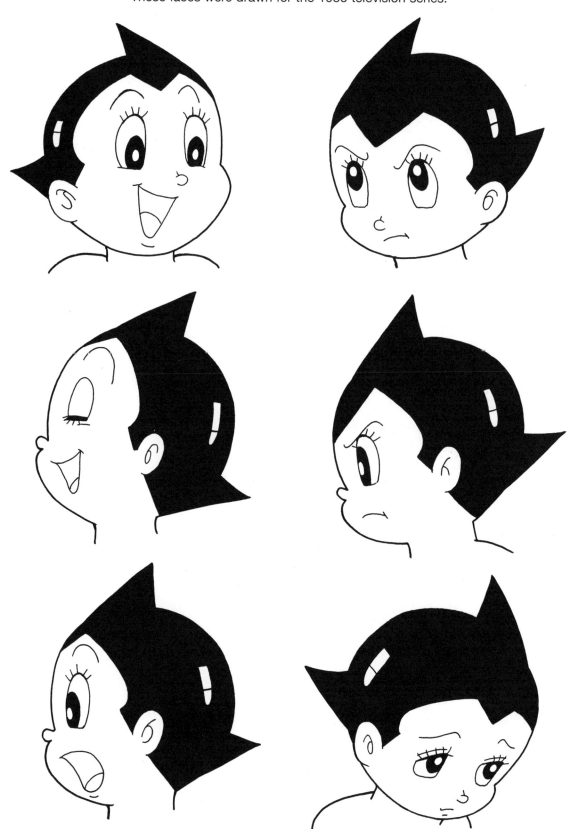

Drawing the hands and arms •••••••••• Part 1

The relationship between the arms, feet and torso

The two drawings on the right compare a young boy and Astro Boy. Their proportions are totally different. The boy has a head-to-height ratio of 1 to 6, and Astro Boy, a ratio of 1 to 3.5. Astro Boy's head is larger than his cylindrical torso; so, in order to have him pose in the same manner as a human, his arms, chest and legs require modification.

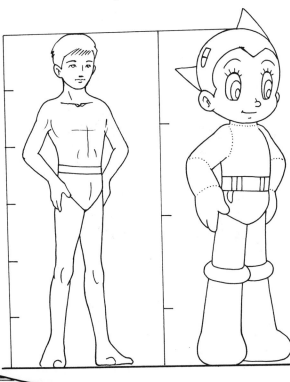

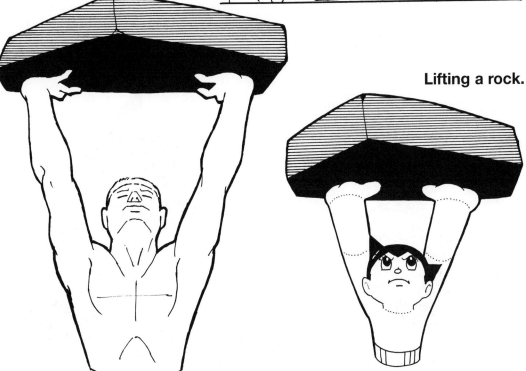

Lifting a rock.

When a man lifts an object, he should appear as in the illustration on the left. Astro Boy, however, has a thick torso and arms. Thus in order to draw Astro Boy lifting a rock, his arms need to be made longer than normal and to be taken behind the head.

Drawing the hands and arms •••••••••• Part 2

By-the-textbook, correctness in drawing Astro Boy can on occasion result in poor expressiveness. A manga-like approach will render Astro Boy as cute or cool.

It is better to show the face and the arms, even if the relationship between them is unnatural.

This is how you would expect Astro Boy to look. However, this form is not attractive.

Correct but odd-looking

A manga-like rendering

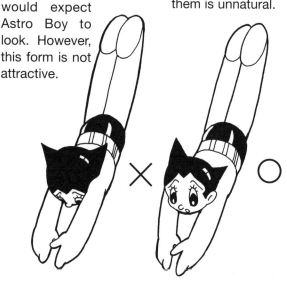

In this pose, Astro Boy would normally appear as he does on the left. Showing his face is one example of modification.

The hands, arms and face should appear in relation to one another as they do at left. But it's better to take manga-like approach and show the face.

Astro Boy with outstretched arms

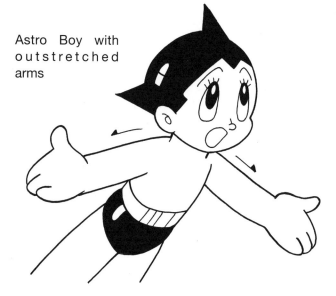

When the arms are outstretched in this fashion, the shoulders become straight.

Shrugging the shoulders to an exaggerated degree

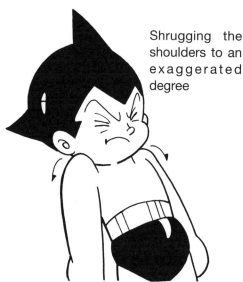

When scolded or surprised, Astro Boy shrugs his shoulders like this.

Drawing the hand •••••••••••••••••••• *Part* 1

Structure of the hand and its simplification

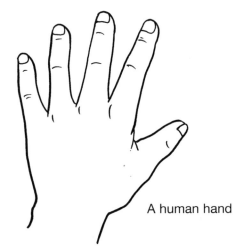

A human hand

A realistically drawn palm

To draw Astro Boy's hand, first sketch the palm as a circle. Next add the thumb and other fingers.

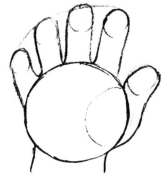

The details follow next. Astro Boy's hand is particularly manga-ish and cute.

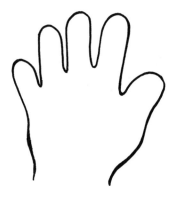

When drawing the hand, consider which parts should be drawn thick to convey a manga-like, 3D feel. The combination of thick and thin lines gives the hand a realistic appearance when drawn close up.

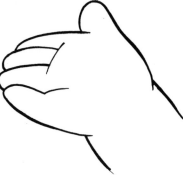

Drawing the hand ●●●●●●●●●●●●●●●●● Part 2

Various fists and hands

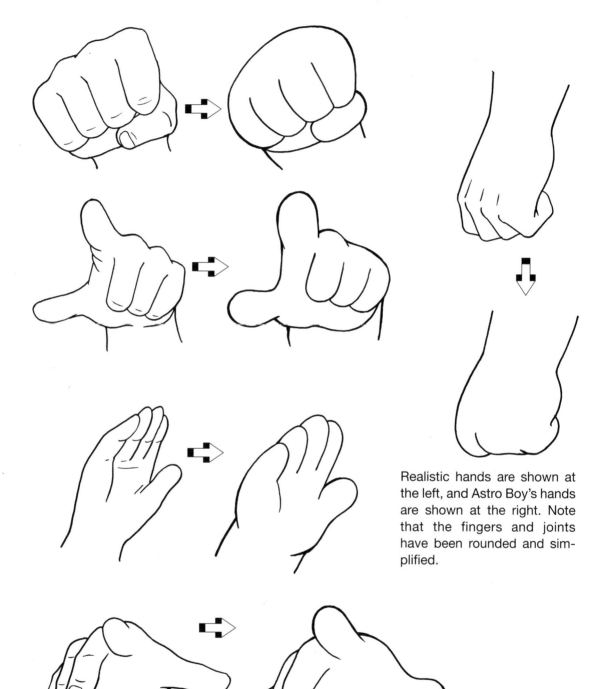

Realistic hands are shown at the left, and Astro Boy's hands are shown at the right. Note that the fingers and joints have been rounded and simplified.

Drawing the hand •••••••••••••••••••••• *Part* **3**

Various hands

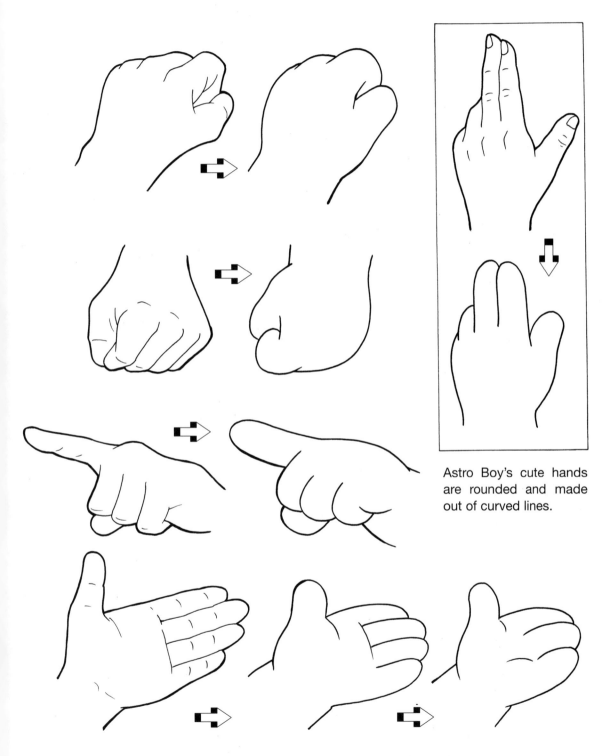

Astro Boy's cute hands are rounded and made out of curved lines.

The early Astro Boy was often depicted with four fingers.

Drawing the hand

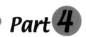

Astro Boy's hands are particularly rounded, even when compared with Tezuka's other creations evolved from circles.

Although there's rarely a need to draw Astro Boy's hands in such a complex manner, if there were ever a situation, they would appear as they do at the right.

How to draw the pants and legs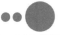

Relationship between the pants and legs

The belt wraps around the body.

Astro Boy's pants snuggly fit his cylindrical legs. Think of his pants as closely resembling a swimsuit.

The soft lines give Astro Boy's legs a feminine look.

The pants are not cut high in the leg.

Pay attention to the buttocks and the wrap of the belt.

Legs with jet propulsion (From the 2003 television series)

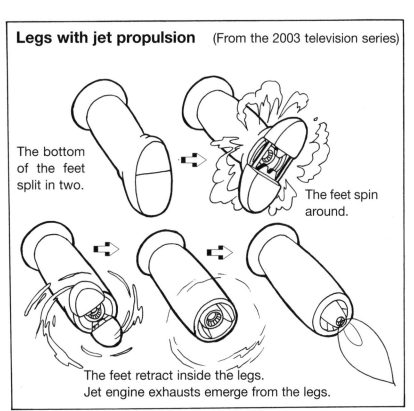

The bottom of the feet split in two.

The feet spin around.

The feet retract inside the legs.
Jet engine exhausts emerge from the legs.

Drawing the legs ●●●●●●●●●●●●●●●●●●●●●●●●●●●●●●

The joints and the soles

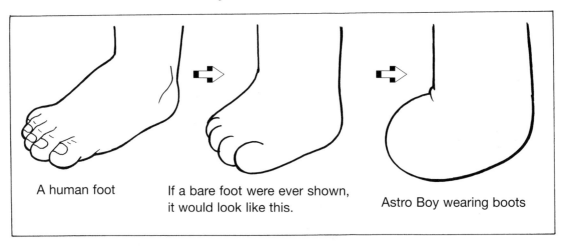

A human foot

If a bare foot were ever shown, it would look like this.

Astro Boy wearing boots

Astro Boy's boots

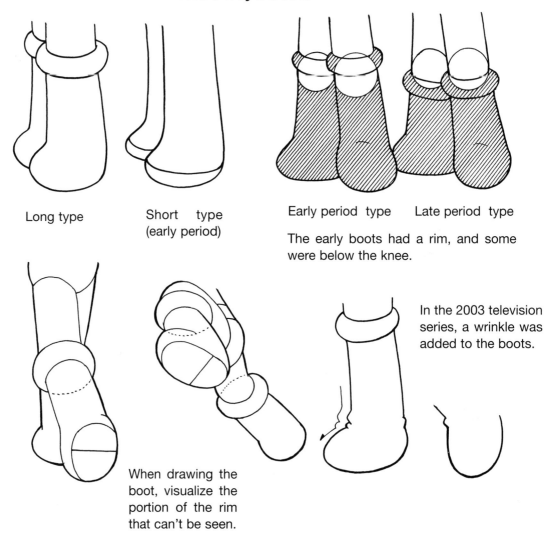

Long type

Short type (early period)

Early period type Late period type

The early boots had a rim, and some were below the knee.

In the 2003 television series, a wrinkle was added to the boots.

When drawing the boot, visualize the portion of the rim that can't be seen.

Let's take a break ●●●●●●●●●●●●●●●●●●●●●●●●●●●

Is Astro Boy's hair soft?

When Astro Boy travels at lightning speed, his hair is swept back.

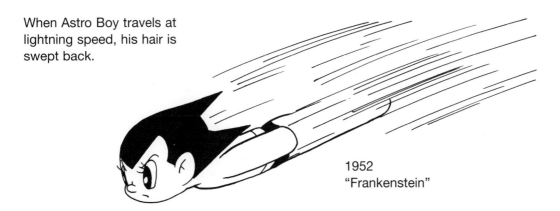

1952
"Frankenstein"

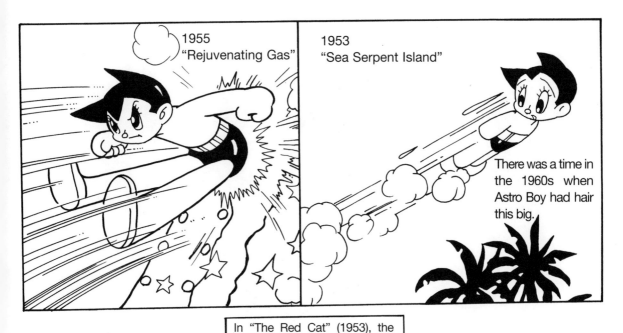

1955
"Rejuvenating Gas"

1953
"Sea Serpent Island"

There was a time in the 1960s when Astro Boy had hair this big.

Astro Boy generally appears with pointy locks and, therefore, his hair is thought to be stiff. However, as these early drawings show, the locks occasionally pointed in different directions or the hair was swept back.

In "The Red Cat" (1953), the pointy locks emphasize the ears' straining to hear something.

Astro Boy's body consists of artificial skin covering a sturdy, but soft, steel exoskeleton. Opinion is divided as to whether Tezuka modeled Astro Boy's hair after his own or after the hair of Norakuro, the protagonist of a favorite childhood manga.

How to draw action scenes

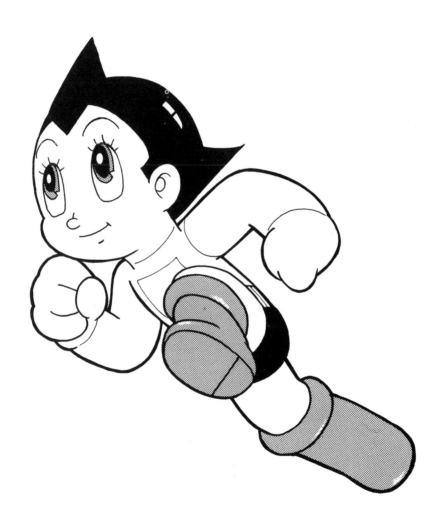

Astro Boy in action-Walking •••••••••• Part 1

Let's see how Astro Boy walks.

When you draw someone walking, it helps to observe people walking or pictures of people walking.

Flesh out the lines and circles.

You can create the flow of the body and impression of walking by means of circles and lines.

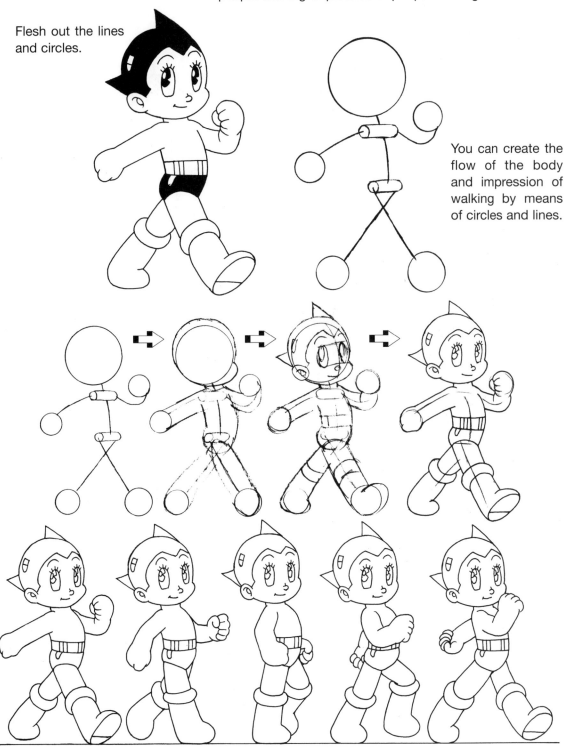

Astro Boy walking

Various patterns

These drawings show Astro Boy walking in different ways from various angles. In the original manga, there are a surprising number of times when Astro Boy appears downhearted. Here, however, he's in an upbeat mood.

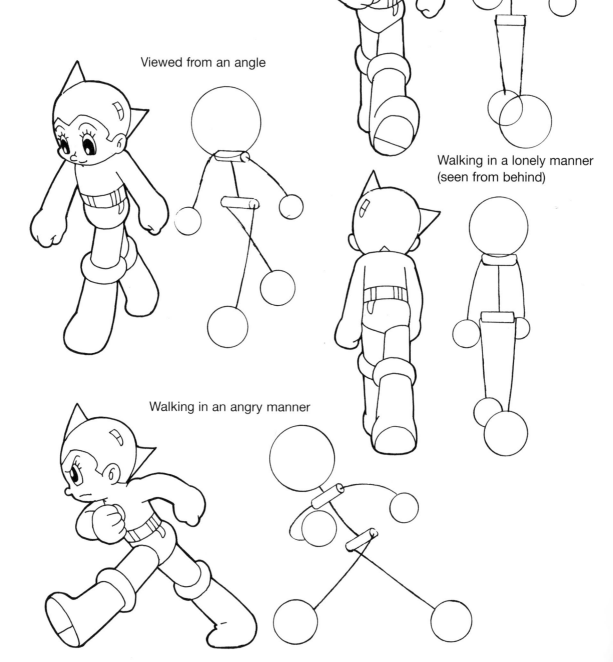

Beaming excitedly

Viewed from an angle

Walking in a lonely manner
(seen from behind)

Walking in an angry manner

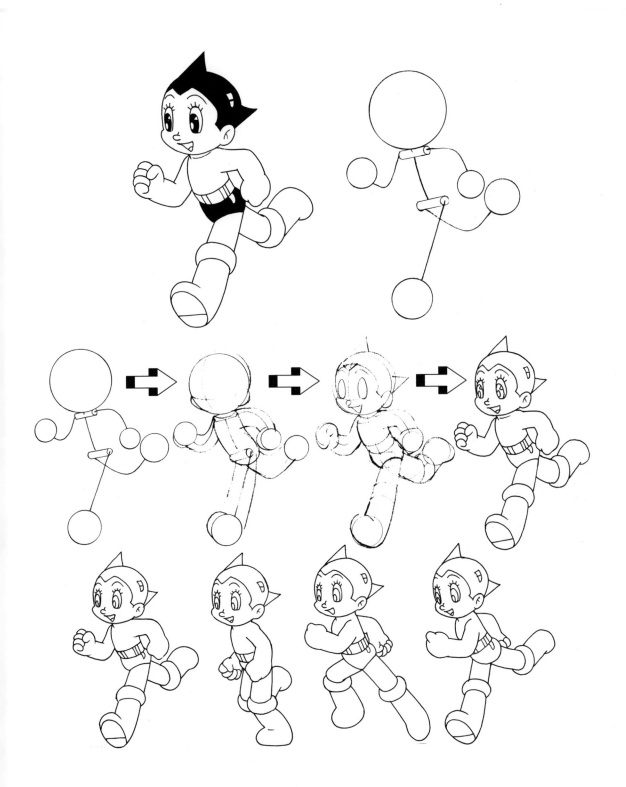

Astro Boy in action–running

 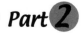

Running styles

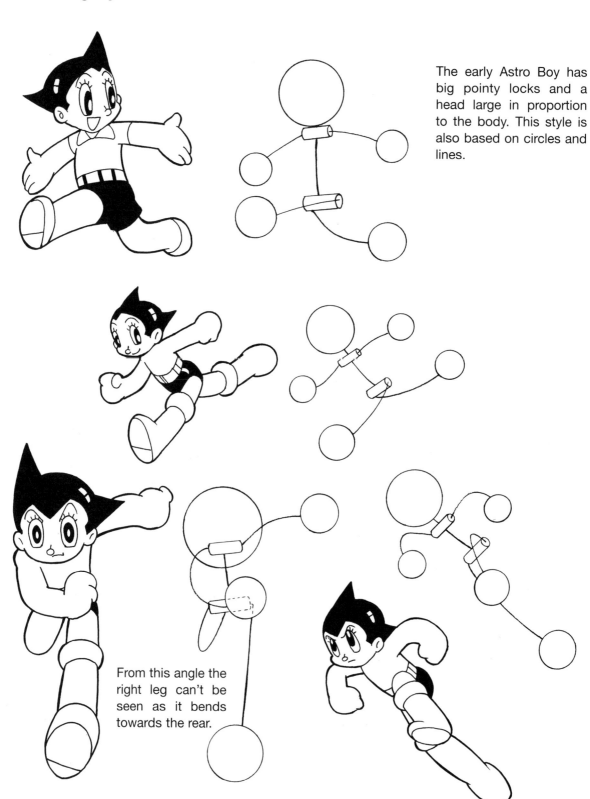

The early Astro Boy has big pointy locks and a head large in proportion to the body. This style is also based on circles and lines.

From this angle the right leg can't be seen as it bends towards the rear.

Astro Boy in daily life—thinking •••••• Part ①

Let's draw Astro Boy in steps from the initial outline.

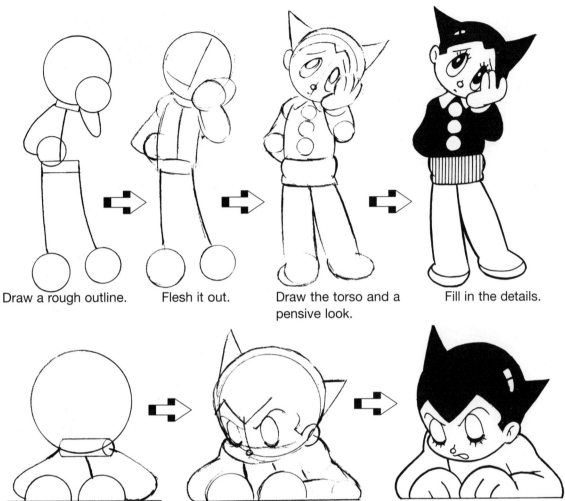

Draw a rough outline.

Flesh it out.

Draw the torso and a pensive look.

Fill in the details.

The angle of the head and expression are crucial in drawing the upper body.

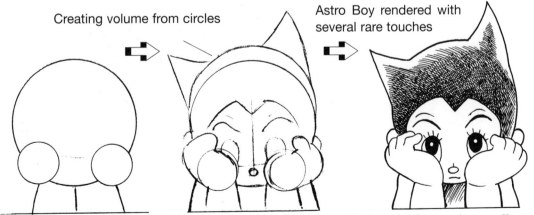

Creating volume from circles

Astro Boy rendered with several rare touches

When Astro Boy is thinking, his eyes should be fixed on a single point for maximum effect.

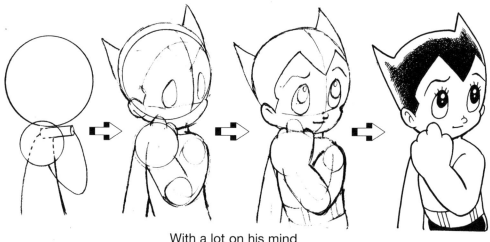

With a lot on his mind

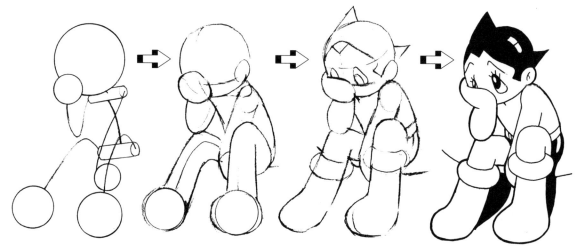

Deep in thought

Shading indicates the direction of the light.

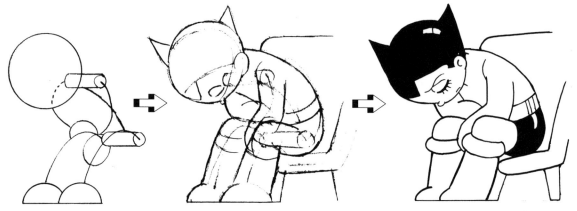

The deepest posture possible.

Astro Boy in action–surprise/fright ••• Part 1

Here Astro Boy recoils in surprise. With the pen draw flowing lines that convey movement.

Based on a rough outline, draw the details.

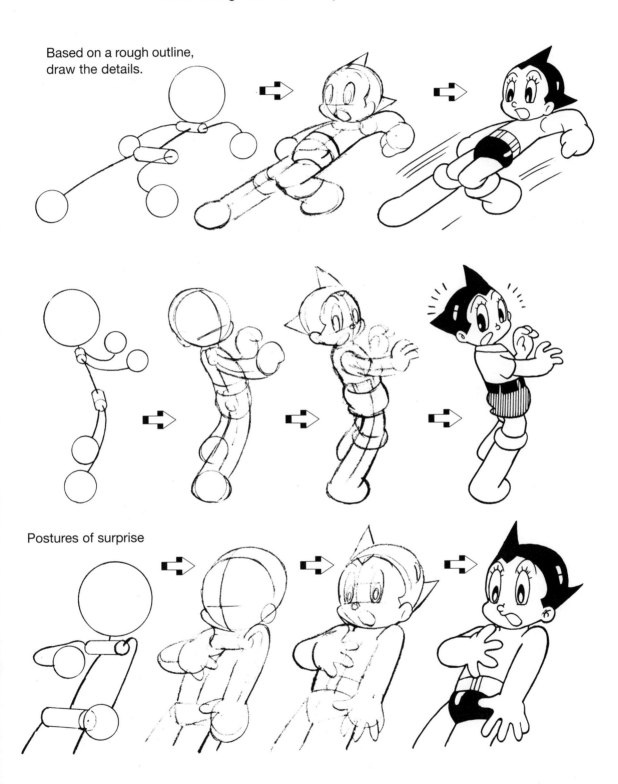

Postures of surprise

There are different degrees of surprise. The drawing will vary according to the degree of surprise.

Stunned or restrained surprise

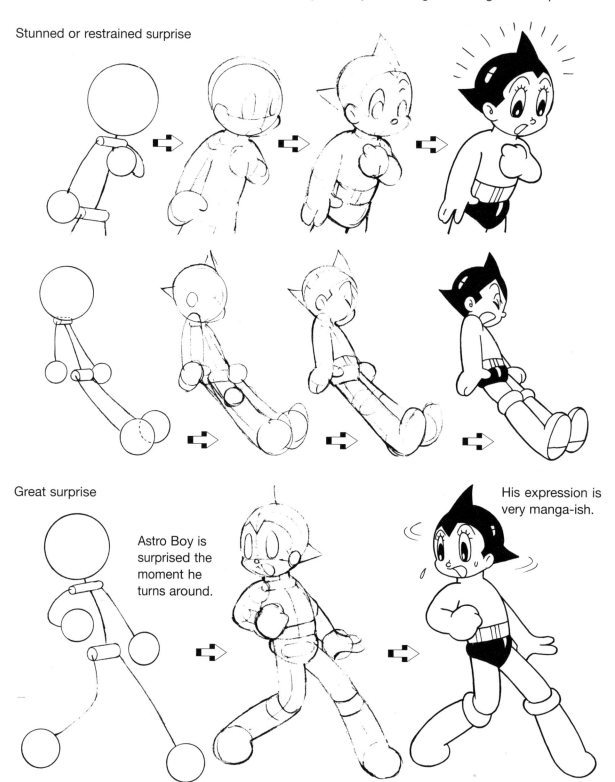

Great surprise

Astro Boy is surprised the moment he turns around.

His expression is very manga-ish.

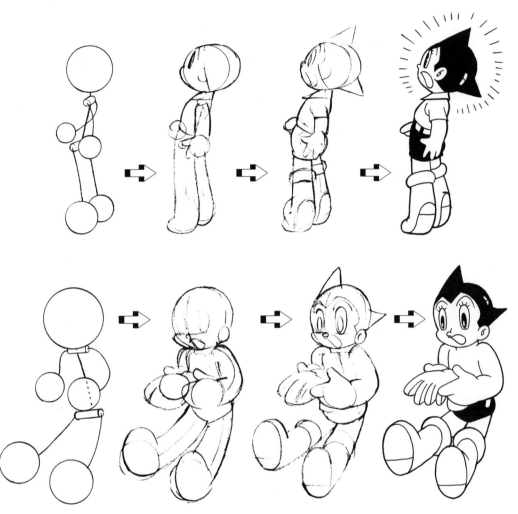

Unexaggerated, moderate surprise

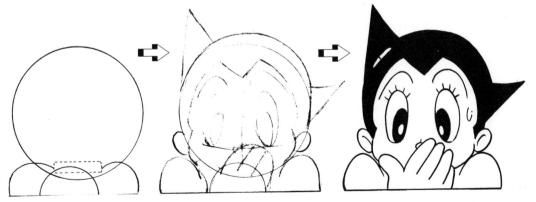

A close-up of a surprised expression

Draw the centerline and the outlines of the eyes.

Draw the details.

Astro Boy in action—flying ●●●●●●●●●●●●● *Part* 1

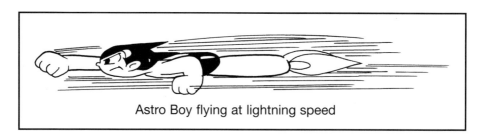

Astro Boy flying at lightning speed

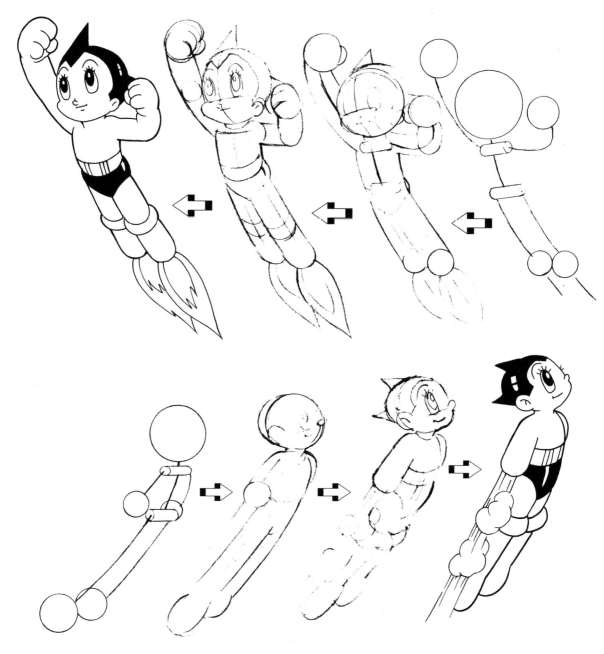

The early Astro Boy's arms emitted exhaust and smoke.

Astro Boy in action—flying

Astro Boy strikes his coolest, most conspicuous pose when in flight. Here he appears an angle from below, at an angle from behind, from the front and at an angle from above. Of course, there are many other ways to depict him in flight.

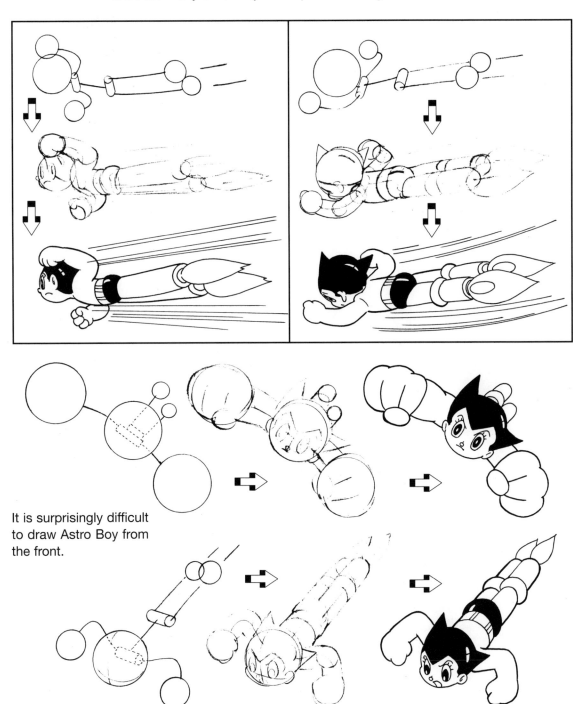

It is surprisingly difficult to draw Astro Boy from the front.

Astro Boy in action—flying •••••••••••• Part 3

Astro Boy hops skyward.

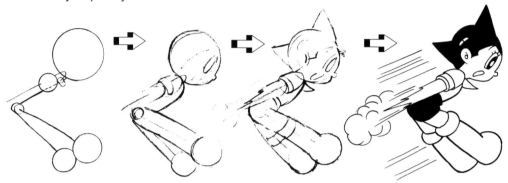

This classic drawing shows from below a bootless Astro Boy in flight.

This type of posture is difficult to draw

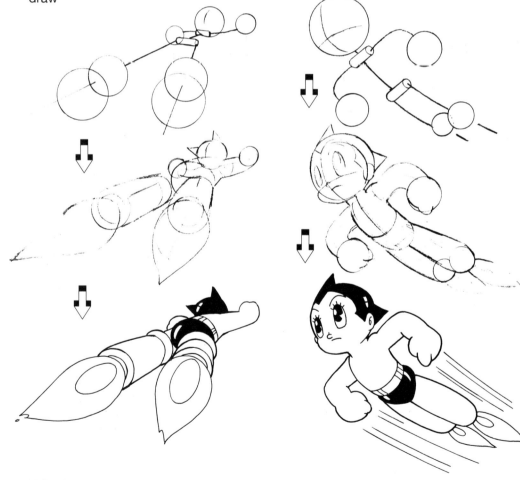

Astro Boy in action—flying •••••••••••• *Part* 4

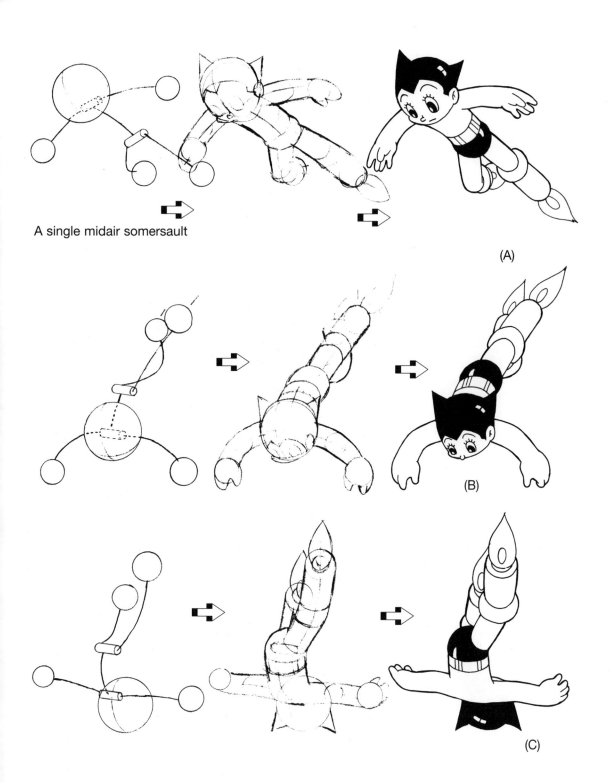

A single midair somersault

(A)

(B)

(C)

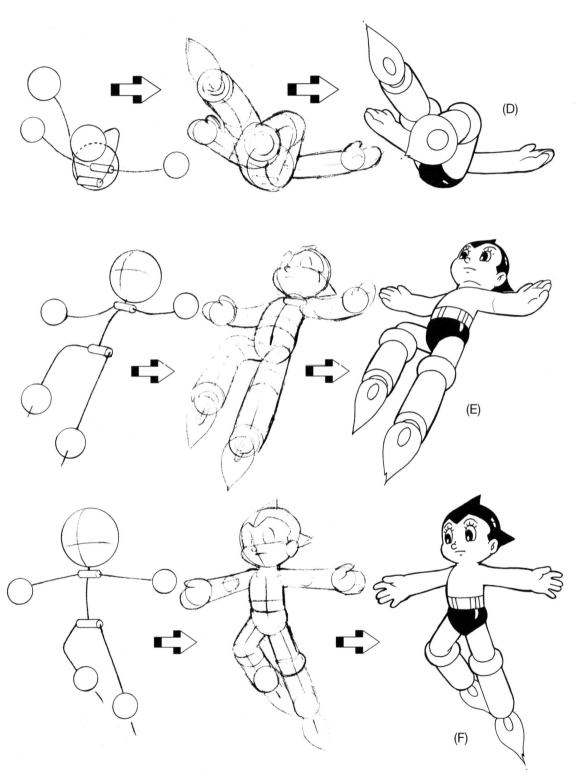

(D)

(E)

(F)

He is now ready to return to (A).

Astro Boy in action—flying •••••••••••• Part 6

Use of flowing lines

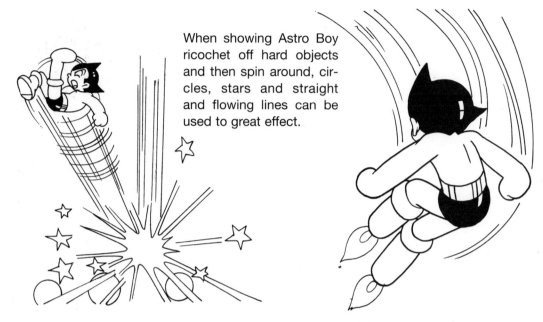

When showing Astro Boy ricochet off hard objects and then spin around, circles, stars and straight and flowing lines can be used to great effect.

The use of flowing lines enables the expression of a somersault.

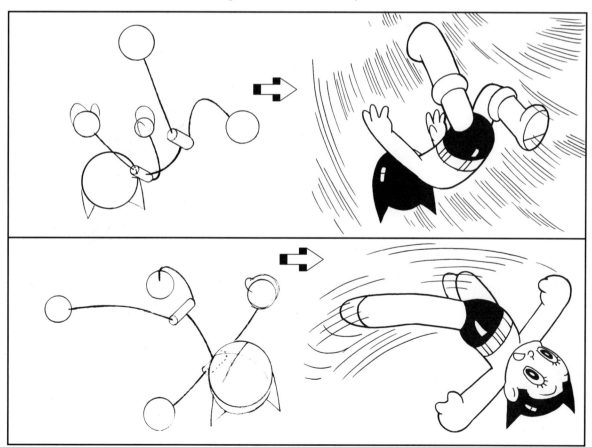

Astro Boy in action—flying •••••••••••• Part 7

Various flying postures

Hovering in midair

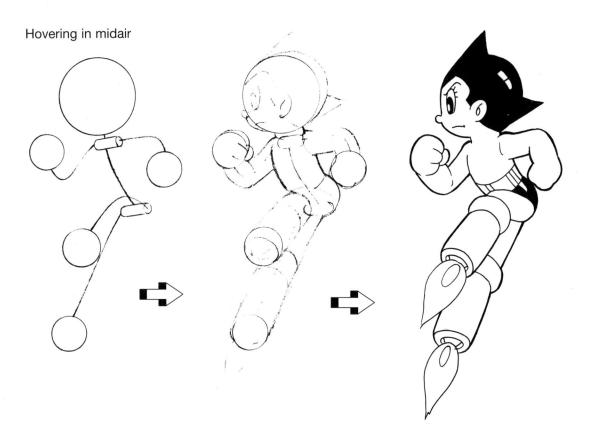

Jumping by means of his arm jet engines

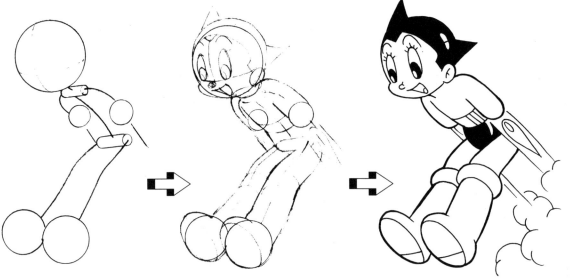

Use circles and lines to get the right feel.

As a final touch, draw flowing lines and the jet exhaust.

Astro Boy in action–flying •••••••••••• Part 8

Reversing and hovering

Astro Boy can fly in various directions.
Here he's flying backwards.

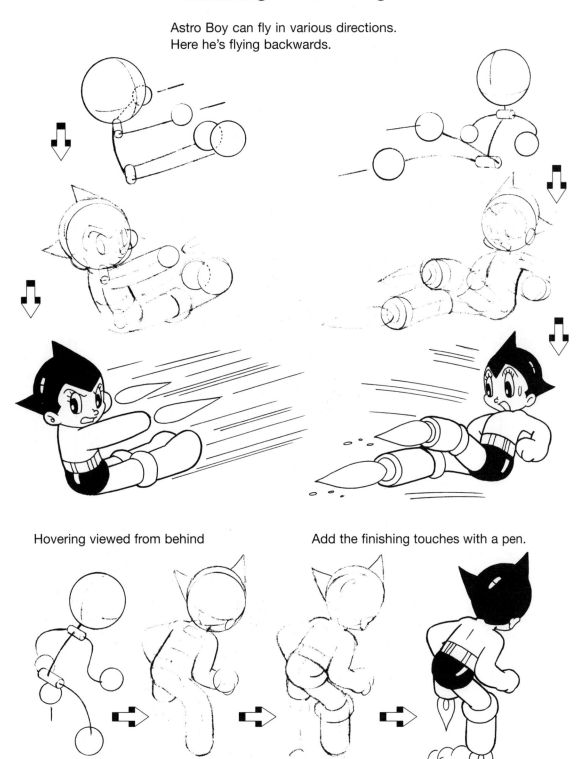

Hovering viewed from behind

Add the finishing touches with a pen.

Flying with someone in his arms

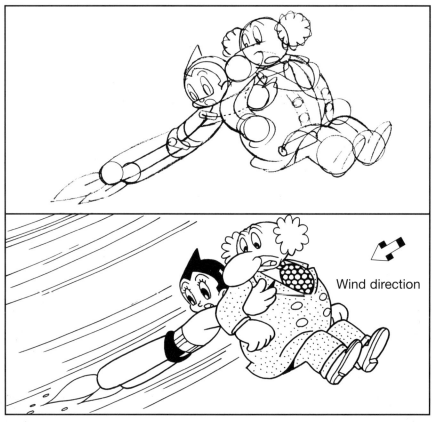

Ensure there is variation in the lines expressing direction of movement.

Wind direction

Considering the direction of the wind, the hair should appear like this. In Tezuka's manga, however, the hair is not affected by the wind.

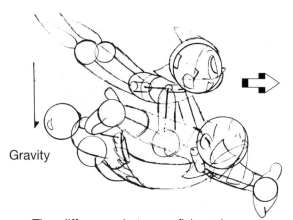

Gravity

The difference between flying alone and flying while holding something is that in the latter case gravity exerts a downward force.

Keeping this in mind, the drawing conveys the weight of Higeoyaji.

Astro Boy in action—touchdown ●●●●●● Part 1

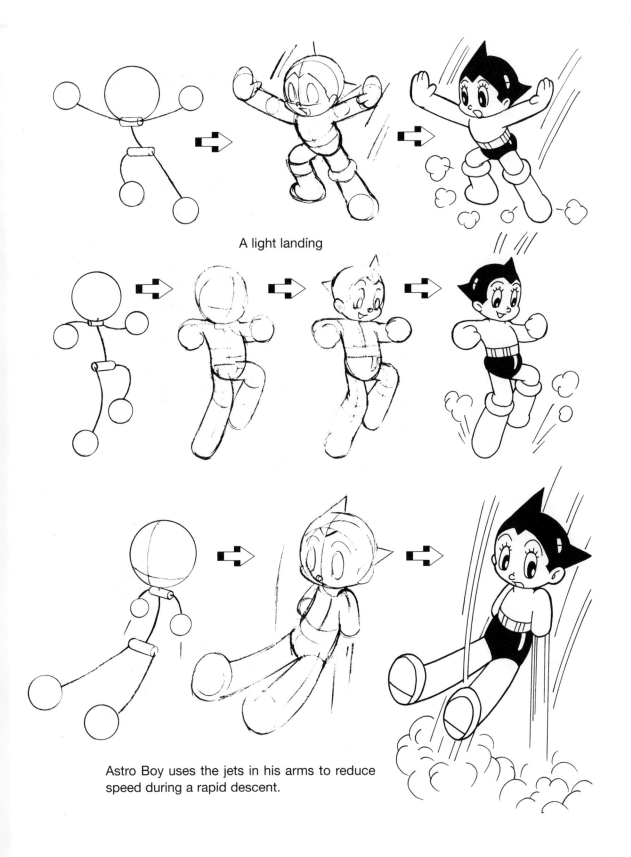

A light landing

Astro Boy uses the jets in his arms to reduce speed during a rapid descent.

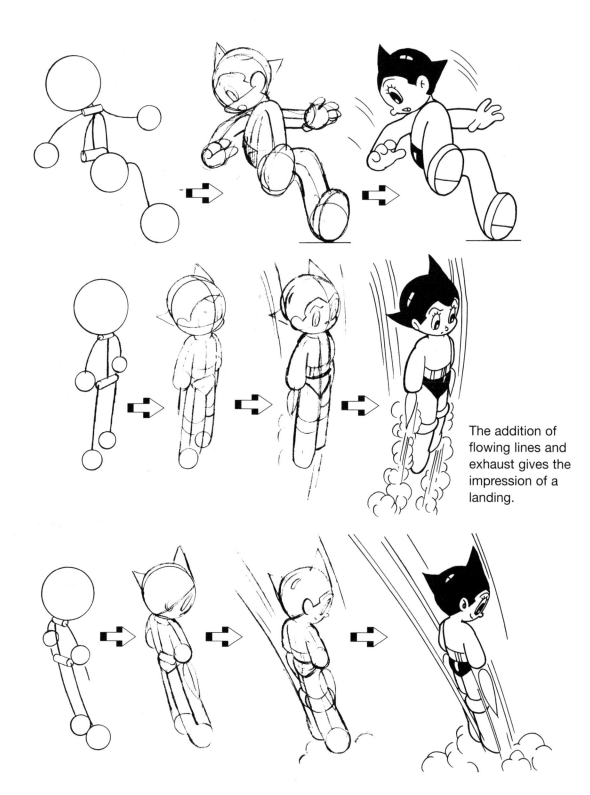

The addition of flowing lines and exhaust gives the impression of a landing.

Smoke is a further added for realistic touch.

Astro Boy in action–touchdown •••••• Part

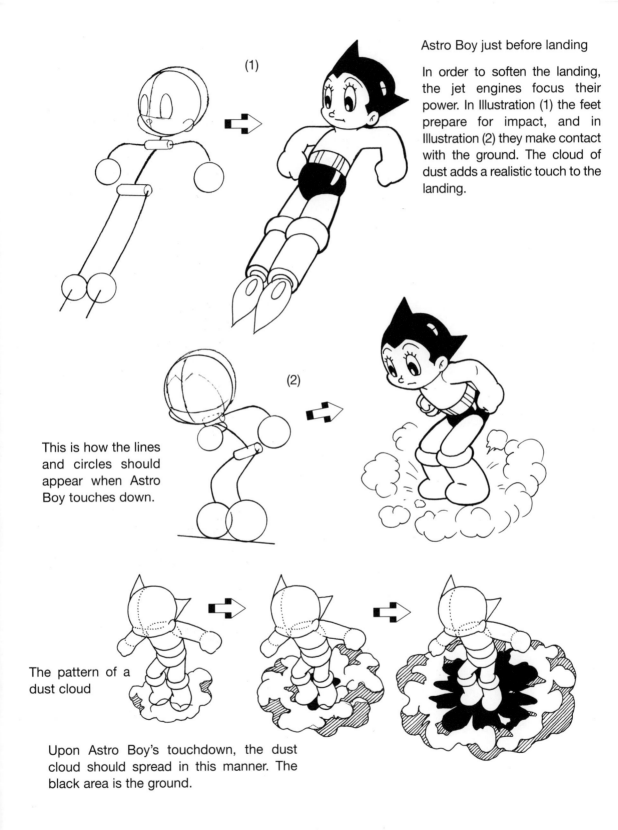

(1)

Astro Boy just before landing

In order to soften the landing, the jet engines focus their power. In Illustration (1) the feet prepare for impact, and in Illustration (2) they make contact with the ground. The cloud of dust adds a realistic touch to the landing.

(2)

This is how the lines and circles should appear when Astro Boy touches down.

The pattern of a dust cloud

Upon Astro Boy's touchdown, the dust cloud should spread in this manner. The black area is the ground.

Astro Boy in action–touchdown and takeoff ••• Part 1

Seen from the front

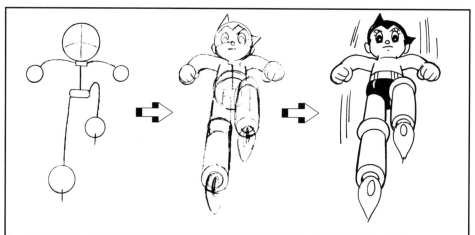

While there are few occasions to draw Astro Boy from the front, here are a few animation-like examples of how to draw him from this difficult perspective.

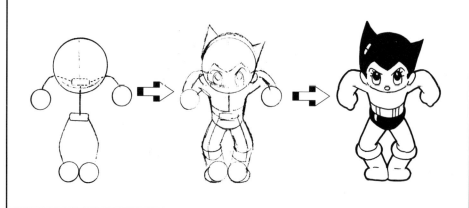

Before he takes off, he bends his knees slightly .

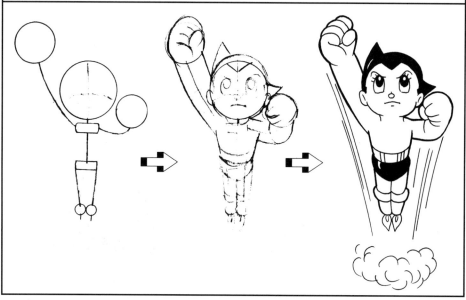

Here he's in full flight. The addition of smoke and other details creates a dynamic look.

Astro Boy in action–touchdown and takeoff ••• Part ②

Seen from an angle

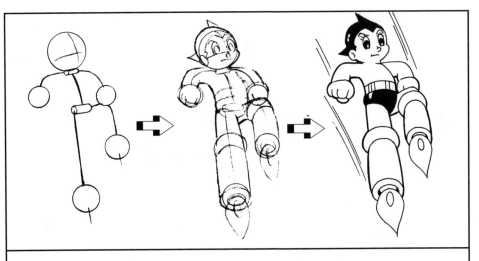

The three frames depict a sequence of actions. Establish the form with circles and lines, and then flesh it out.

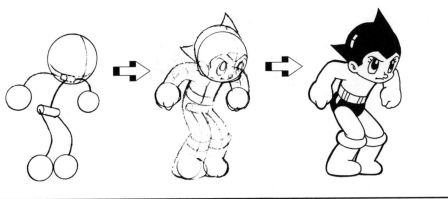

Preparing to blast off

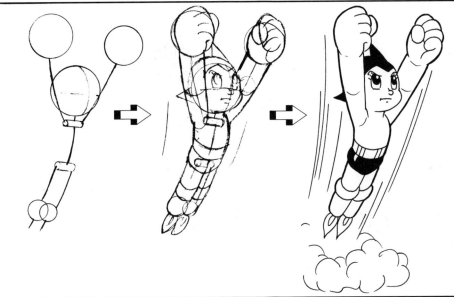

In this right-oriented drawing, he thrusts his arms forward in a posture of vigor.

The finishing touches include flowing lines and jet exhaust at the bottom.

Astro Boy in action–touchdown and takeoff ••• Part 3

Seen from a reverse angle

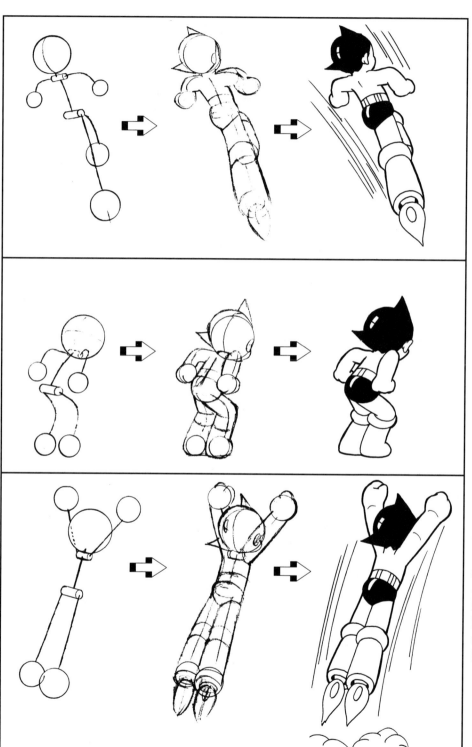

Here Astro Boy is drawn in a difficult pose from a reverse angle.

As in Parts (1) and (2), here Astro Boy is shown in a sequence of actions.

Once again Astro Boy shoots skyward. Now try your hand at drawing him from above and directly behind.

Astro Boy in action—fighting •••••••••• *Part*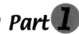

Fighting stance

Here are various poses of Astro Boy bracing for a fight. Because he is not yet fighting, many of these poses convey comparatively little action.

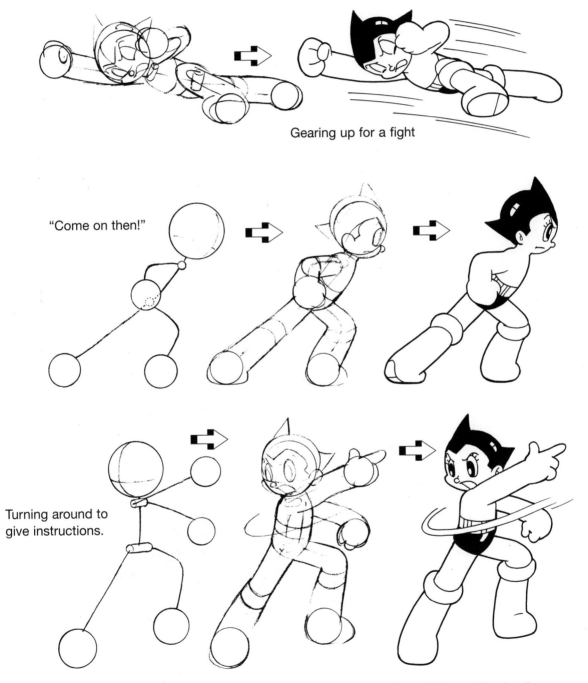

Gearing up for a fight

"Come on then!"

Turning around to give instructions.

The addition of flowing lines breathes life into the illustration.

Fighting stance

The drawings convey easy, fluent movement.

Fighting stance

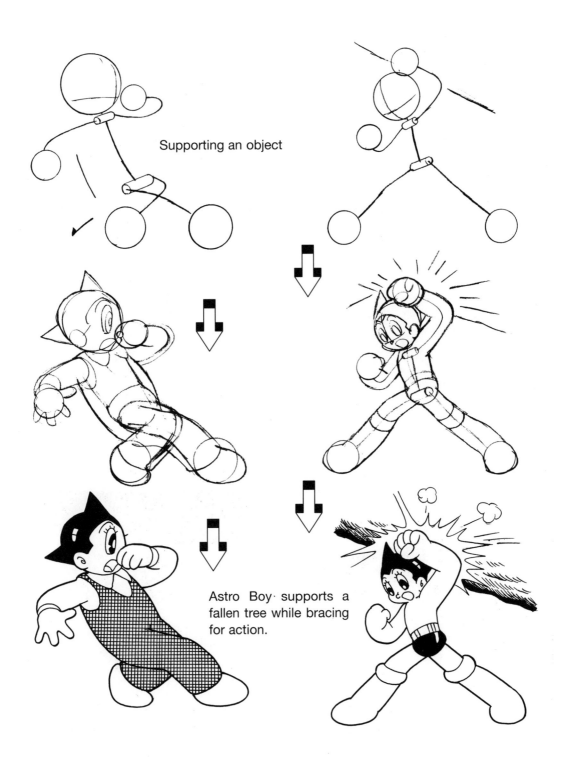

Supporting an object

Astro Boy supports a fallen tree while bracing for action.

Astro Boy in action–fighting 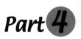 Part 4

Throwing

The follow through after throwing an object

Astro Boy before he throws the object.

Flesh out the drawing.

Add flowing lines to create a drawing full of movement.

Add ink to create movement.

Astro Boy in action–fighting

Before and after throwing

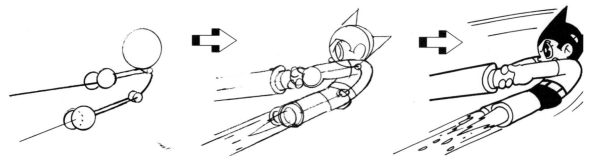

Here is Astro Boy just before he throws an enemy robot by the arm. The flames from his rocket legs invigorate the drawing.

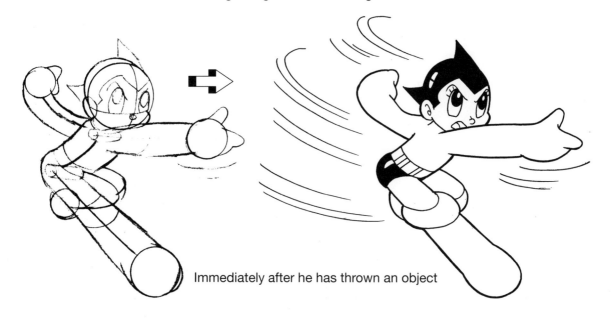

Immediately after he has thrown an object

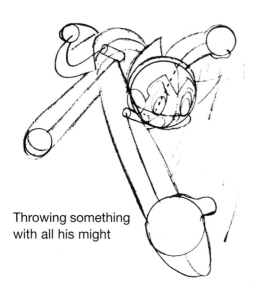

Throwing something with all his might

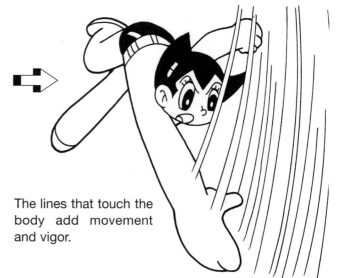

The lines that touch the body add movement and vigor.

Astro Boy in action—fighting •••••••• *Part* **6**

Details were added to the sketch to create the below drawing of Astro Boy battling a dinosaur.

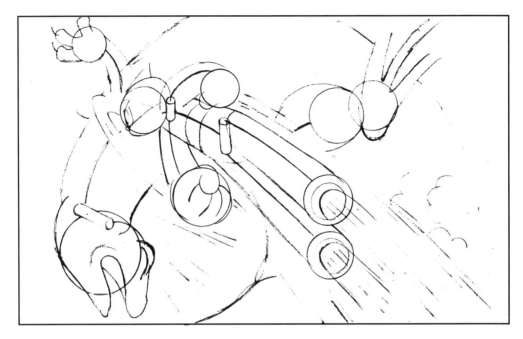

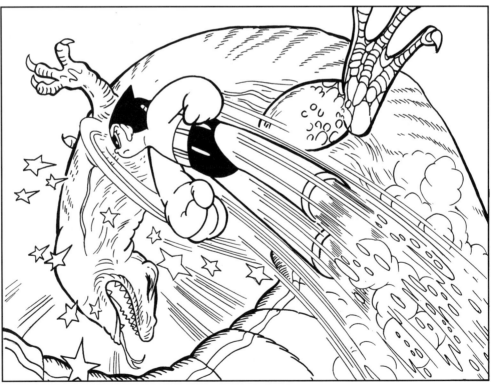

Astro Boy in action—fighting •••••••• *Part*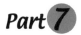

Below are fight scenes with Astro Boy in different poses.

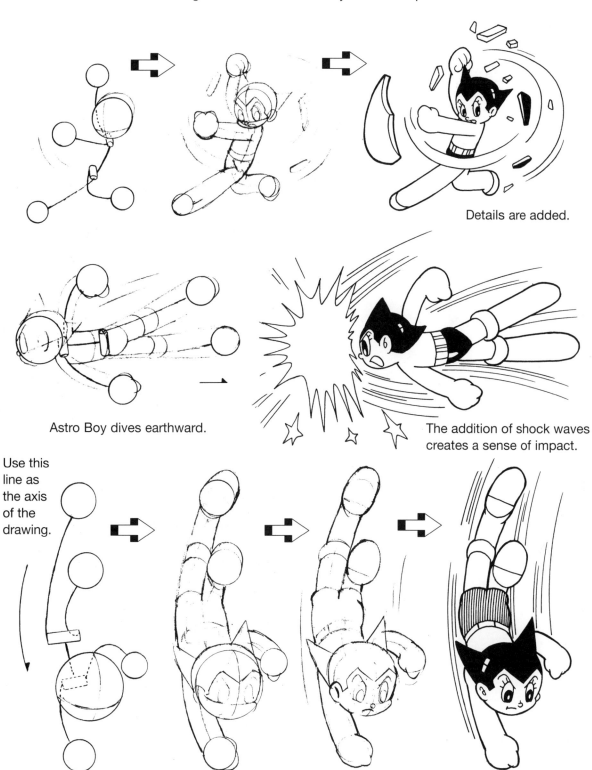

Details are added.

Astro Boy dives earthward.

The addition of shock waves creates a sense of impact.

Use this line as the axis of the drawing.

In drawing Astro Boy pitted against a giant robot, the sweat and wavy lines indicating strain add to the sense of reality. Although an animated way of expression, it fits Astro Boy perfectly.

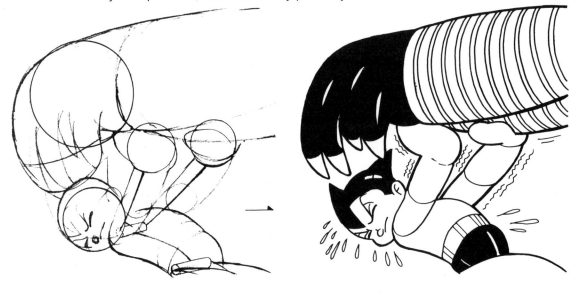

Effects ••• Part ❶ —Explosions and dust clouds

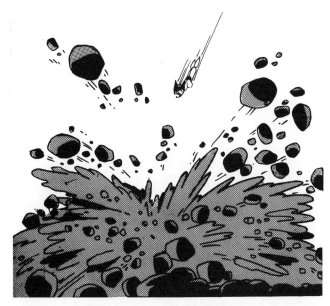

Note the skill with which Tezuka depicts the earth breaking up as Astro Boy pursues the enemy robot underground.

The effects used in the manga suit Astro Boy's manga-ish appearance perfectly and add realism.

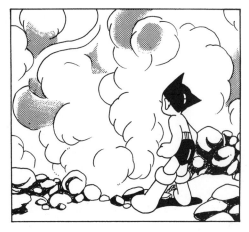

A large cloud of dust. Partial shading makes the cloud look thicker.

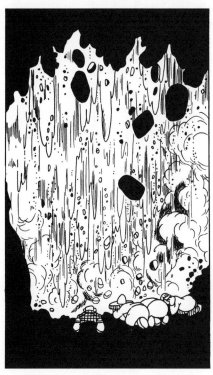

A drawing of a cloud of dust from an explosion.

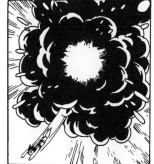

Midair explosion

Although all of these explosions occur in *Astro Boy*, the method of drawing them varies with the scene.

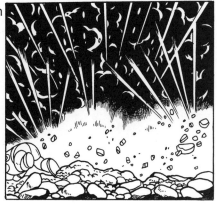

An explosion sends up a cloud of smoke.

Effects ••• Part ②—Water and waves

Tezuka's special effects

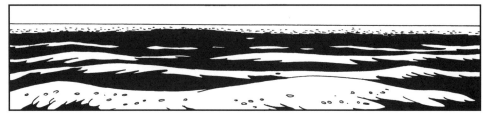

Pictured above are waves breaking upon the beach. Tezuka even applied his unique deformation technique in drawing effects.

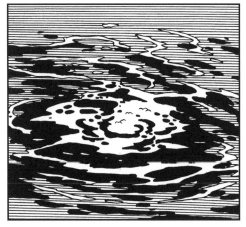

Astro Boy's plunge whipped the water into a whirpool.

The ocean viewed from above. The white waves were drawn to achieve a design effect.

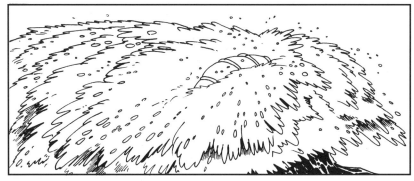

Drawing the surging waves in detail creates a powerful effect. The round tips of the waves are a feature of Tezuka's.

Learn to differentiate wave types. Here Astro Boy flies above a medium-sized wave. The type of wave depends on the action.

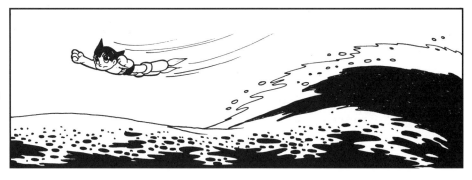

Action poses—Astro Boy in the water ••• Part 1

Through practice it's possible to draw Astro Boy in the water with confidence.

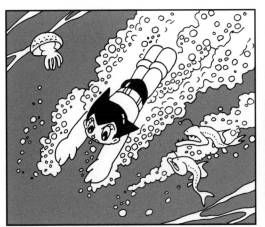
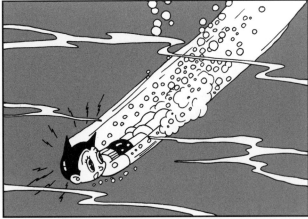

The bubbles, current, and marine life indicate that he's underwater.

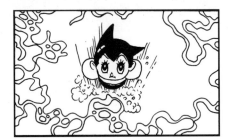

An overhead shot capturing Astro Boy as he bursts out of the sea

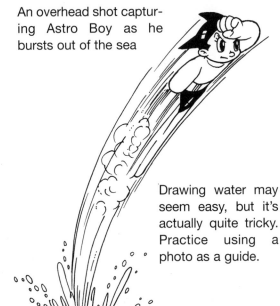

Drawing water may seem easy, but it's actually quite tricky. Practice using a photo as a guide.

Astro Boy blasts off from the sea. Take care in drawing his form.

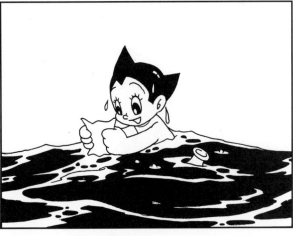

Waves on the ocean surface are drawn differently from undersea currents.

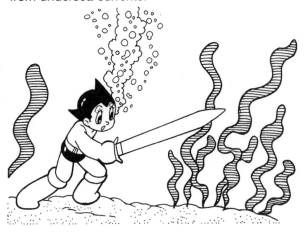

Note the skillful use of bubbles and marine plants.

Action poses—Astro Boy in the water ••• Part 2

Drawing water

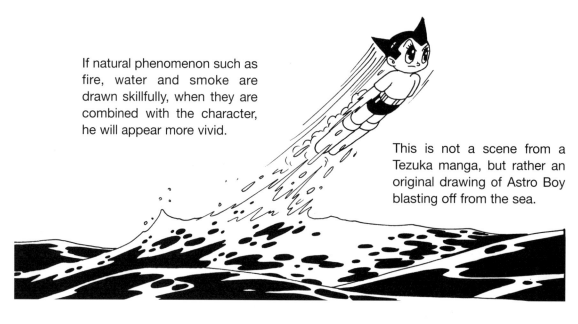

If natural phenomenon such as fire, water and smoke are drawn skillfully, when they are combined with the character, he will appear more vivid.

This is not a scene from a Tezuka manga, but rather an original drawing of Astro Boy blasting off from the sea.

An example of waves drawn poorly

Having everything the same size is monotonous.

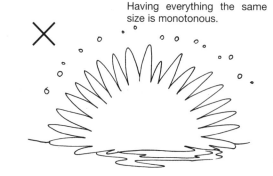

An example of well-drawn waves

Keep in mind the size of the spray and the overall balance in order to create realistic waves.

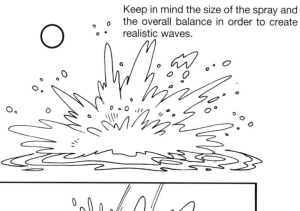

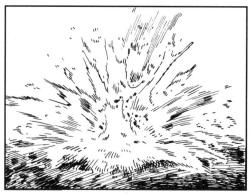

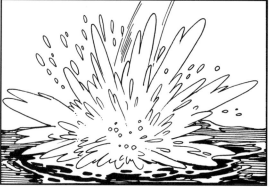

The waves created when Astro Boy hits the water should appear as in the drawing at the left, but Tezuka uses distortion to give the waves a round form.

Action poses–Astro Boy in the water ••• Part 3

Sedate action in water

Rendering a placid body of water such as a lake is different from rendering the sea. The following are a few examples.

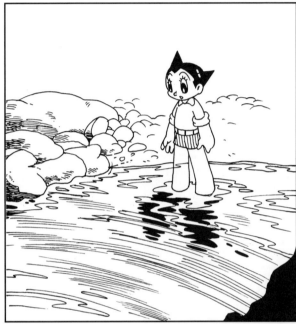

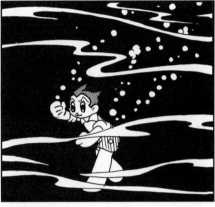

This is how Astro Boy looks looks when diving in search of something underwater.

Take care when drawing the form of water.

The drawing lacks contrast because its elements are all the same size.

Variations in size, thickness and shape produce lifelike water.

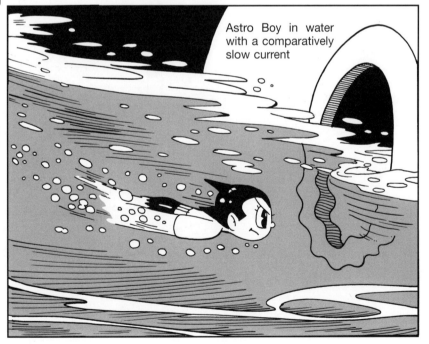

Astro Boy in water with a comparatively slow current

The secrets to drawing action poses –speed and dynamism

There are many ways to represent speed. Some of these share common elements with fighting poses.

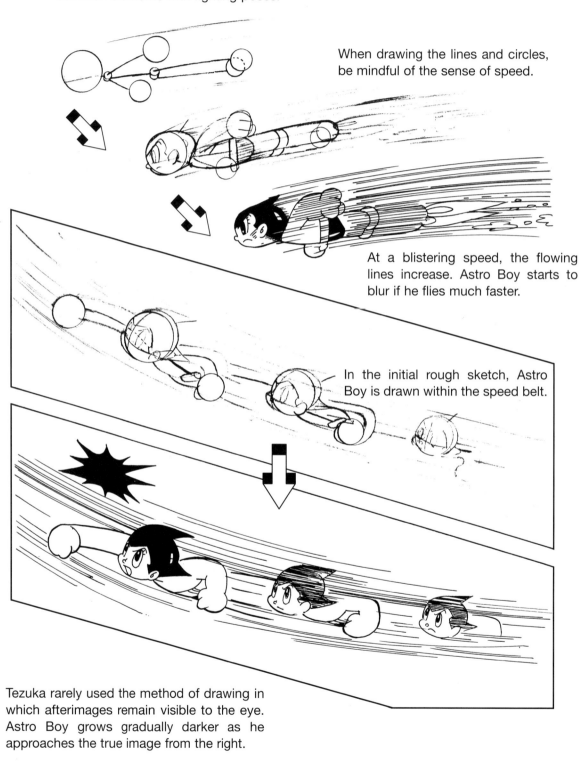

When drawing the lines and circles, be mindful of the sense of speed.

At a blistering speed, the flowing lines increase. Astro Boy starts to blur if he flies much faster.

In the initial rough sketch, Astro Boy is drawn within the speed belt.

Tezuka rarely used the method of drawing in which afterimages remain visible to the eye. Astro Boy grows gradually darker as he approaches the true image from the right.

The secrets to drawing action poses –speed and dynamism

A sequence of frames with continuous movement is an effect used to illustrate action.

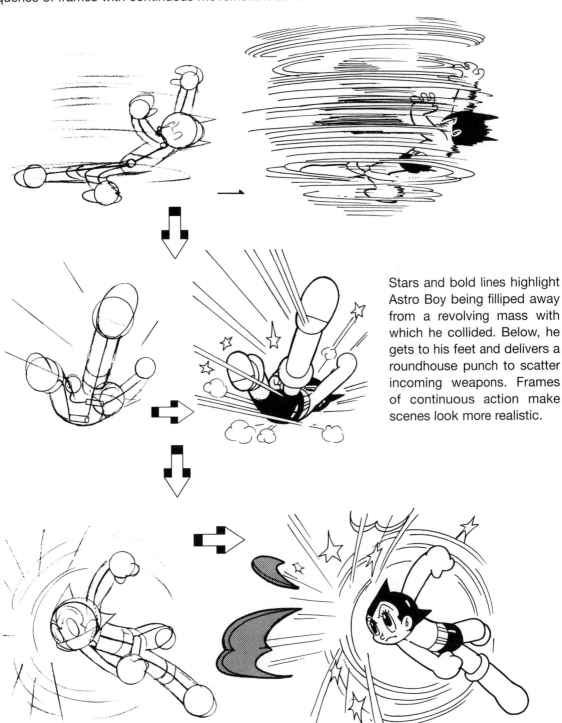

Stars and bold lines highlight Astro Boy being filliped away from a revolving mass with which he collided. Below, he gets to his feet and delivers a roundhouse punch to scatter incoming weapons. Frames of continuous action make scenes look more realistic.

Action poses—creating a heavy appearance ••• Part 1

Astro Boy throws an enormous robot. The foreground is greatly exaggerated, and bold lines and smoke have been added.

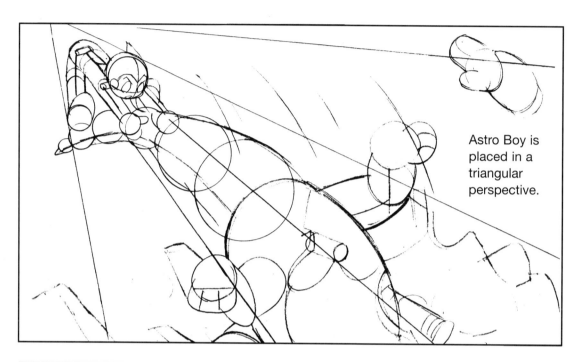

Astro Boy is placed in a triangular perspective.

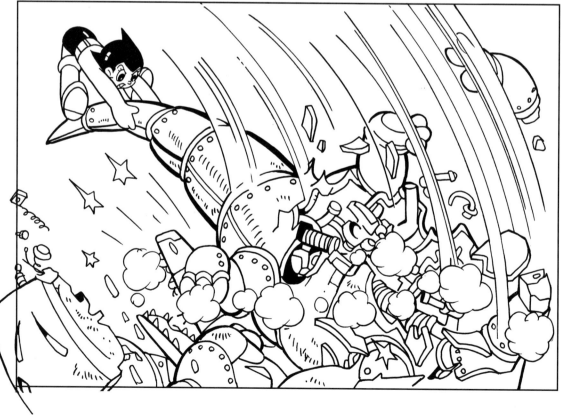

Action poses—creating a heavy appearance ••• *Part* 2

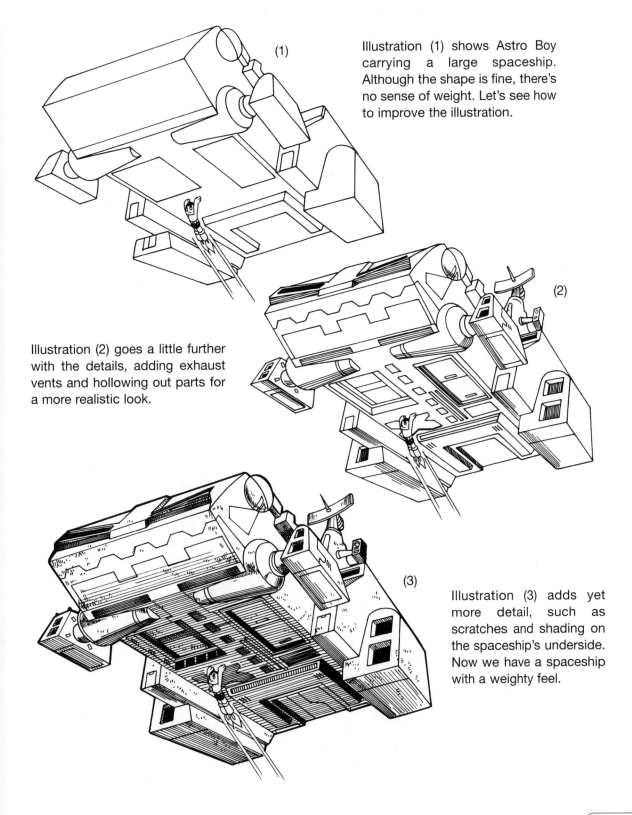

(1)

Illustration (1) shows Astro Boy carrying a large spaceship. Although the shape is fine, there's no sense of weight. Let's see how to improve the illustration.

(2)

Illustration (2) goes a little further with the details, adding exhaust vents and hollowing out parts for a more realistic look.

(3)

Illustration (3) adds yet more detail, such as scratches and shading on the spaceship's underside. Now we have a spaceship with a weighty feel.

Action poses—use of shadows •••••••• Part 1

In real life, a shadow should appear like this.

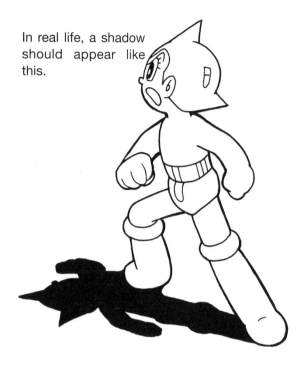

However, it is rounded and simplified to fit the character.

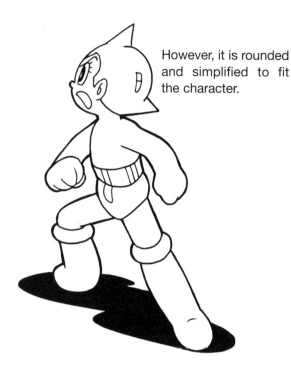

Light source

When a shadow is meaningful, it is made to look real.

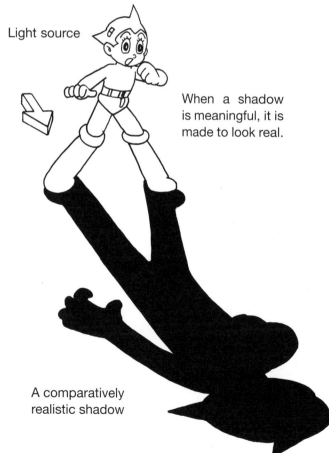

A comparatively realistic shadow

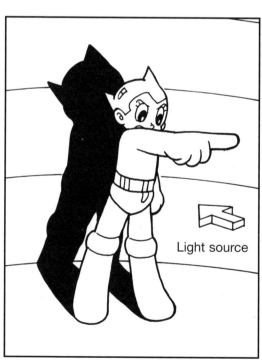

Light source

Sometimes a shadow is used to emphasize the distance from the character to the background.

Action poses—use of shadows •••••••••• Part 2

Sometimes Astro Boy flies low. Placing a shadow several centimeters under him gives him a sense of weight and makes him seem to be floating.

By making the shadow thin, the light can be made to appear faint.

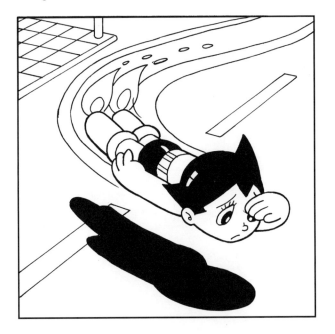

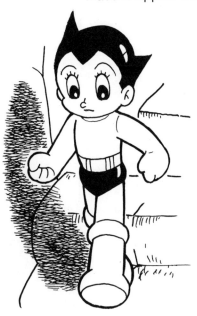

Backlight and direct light

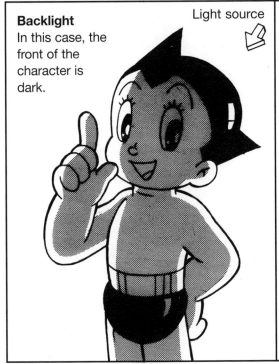

Backlight
In this case, the front of the character is dark.

Light source

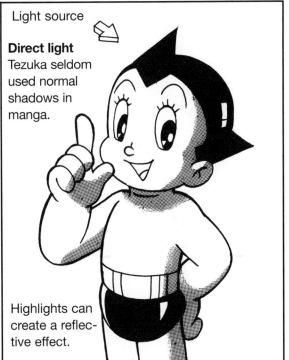

Light source

Direct light
Tezuka seldom used normal shadows in manga.

Highlights can create a reflective effect.

Action poses–miscellaneous •••••••••• Part 1

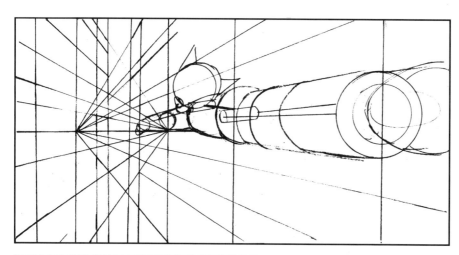

Astro Boy hurtles downward between buildings. When drawing the buildings, create two vanishing points. Draw Astro Boy tailored to the perspective.

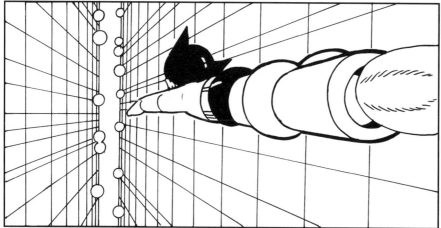

Windows and lighting have not been shown, in order to emphasize the basic design. Next draw the window frames and lighted rooms.

Here you see Astro Boy fighting his way through enemy robots. The robot in the foreground has been drawn larger and with thick lines to highlight the distance to Astro Boy, and to make it seem powerful and realistic.

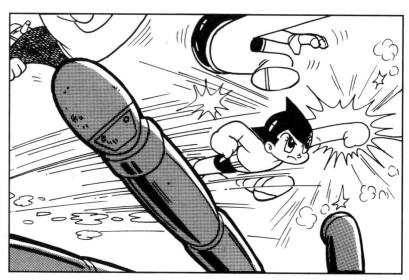

Action poses—miscellaneous

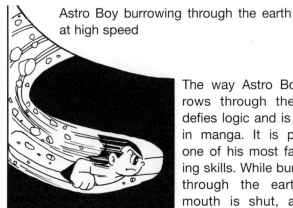

Astro Boy burrowing through the earth at high speed

Up, down or sideways, he moves in any direction.

The way Astro Boy burrows through the earth defies logic and is unique in manga. It is perhaps one of his most fascinating skills. While burrowing through the earth, his mouth is shut, and he wears a fearless look.

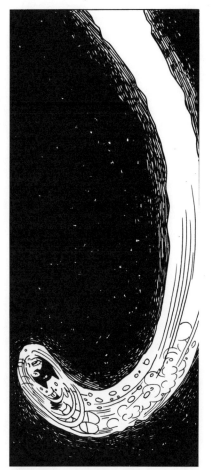

Slow motion analysis

Seen in slow motion, the digging action resembles a crawl stroke that propels him forward in a comical fashion.

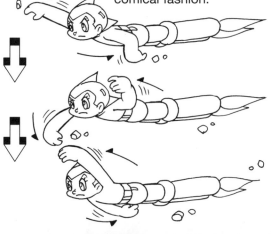

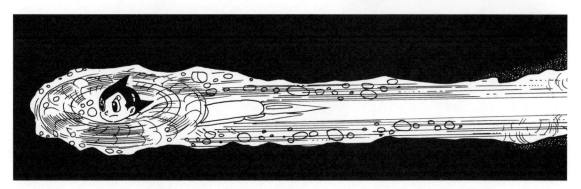

While it may look like digging requires an enormous amount of energy, Astro Boy's progress does not conform to the laws of nature.

Action poses–miscellaneous •••••••••• Part 3

Projecting power

Each illustration shows Astro Boy with an arm thrust out in front. Exaggeration of the hand creates a powerful look.

The enormous robot, which has fallen in the foreground, has been greatly exaggerated in size.

Action poses—miscellaneous •••••••••• Part 4

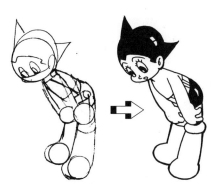

"What's that?"

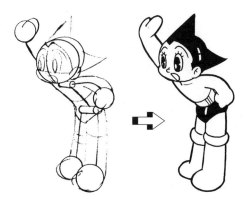

"Hey, I'm over here!"

"I'm not letting you go!"

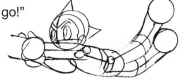
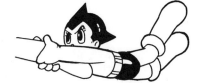

Shocked

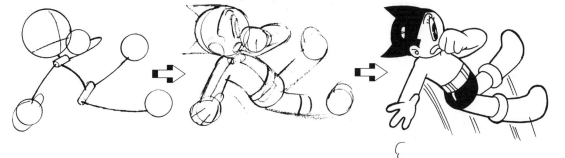

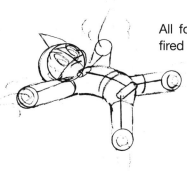

All four engines are fired up for a fight

Common mistakes ••• Part ❶—Head and face

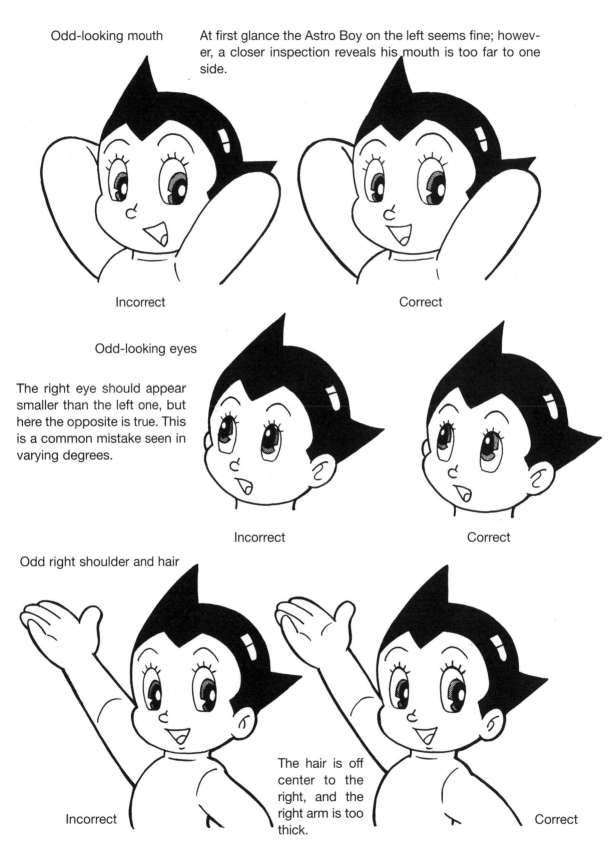

Odd-looking mouth

At first glance the Astro Boy on the left seems fine; however, a closer inspection reveals his mouth is too far to one side.

Incorrect

Correct

Odd-looking eyes

The right eye should appear smaller than the left one, but here the opposite is true. This is a common mistake seen in varying degrees.

Incorrect

Correct

Odd right shoulder and hair

The hair is off center to the right, and the right arm is too thick.

Incorrect

Correct

Common mistakes ••• Part 2 —Body

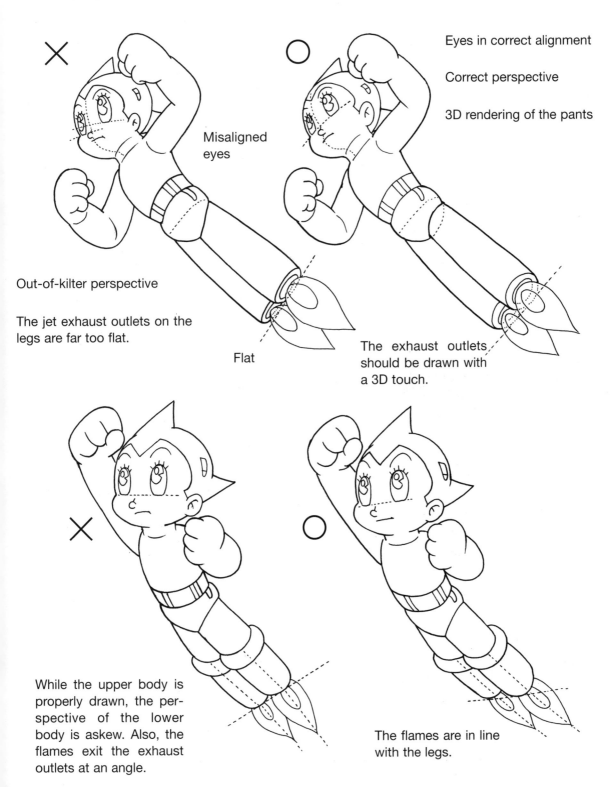

Poor perspective!

✕

Misaligned
eyes

Eyes in correct alignment

Correct perspective

3D rendering of the pants

○

Out-of-kilter perspective

The jet exhaust outlets on the
legs are far too flat.

Flat

The exhaust outlets
should be drawn with
a 3D touch.

✕

○

While the upper body is
properly drawn, the per-
spective of the lower
body is askew. Also, the
flames exit the exhaust
outlets at an angle.

The flames are in line
with the legs.

Common mistakes ••• Part 3 —Body

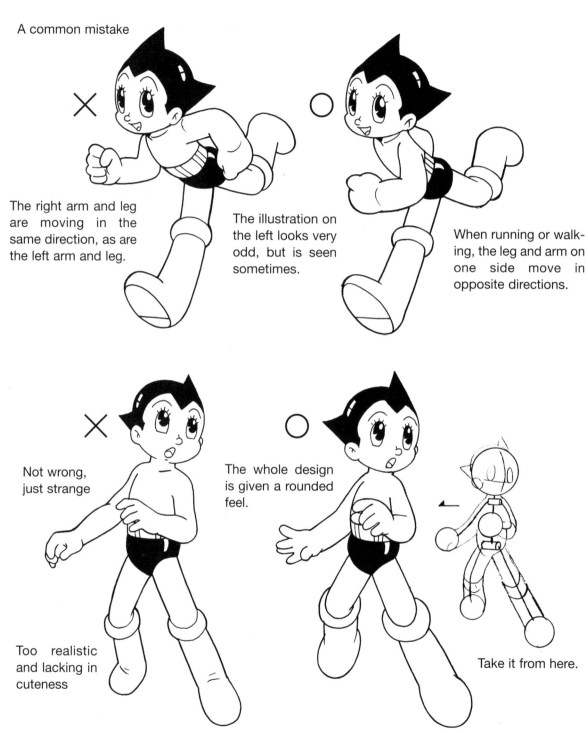

A common mistake

The right arm and leg are moving in the same direction, as are the left arm and leg.

The illustration on the left looks very odd, but is seen sometimes.

When running or walking, the leg and arm on one side move in opposite directions.

Not wrong, just strange

The whole design is given a rounded feel.

Take it from here.

Too realistic and lacking in cuteness

Avoid drawing the shoulders and joints too realistically.

The hands and feet are rounded and made a little larger.

Let's take a break—propulsion

Astro Boy's jet propulsion has been drawn in a variety of ways. Here are some of them.

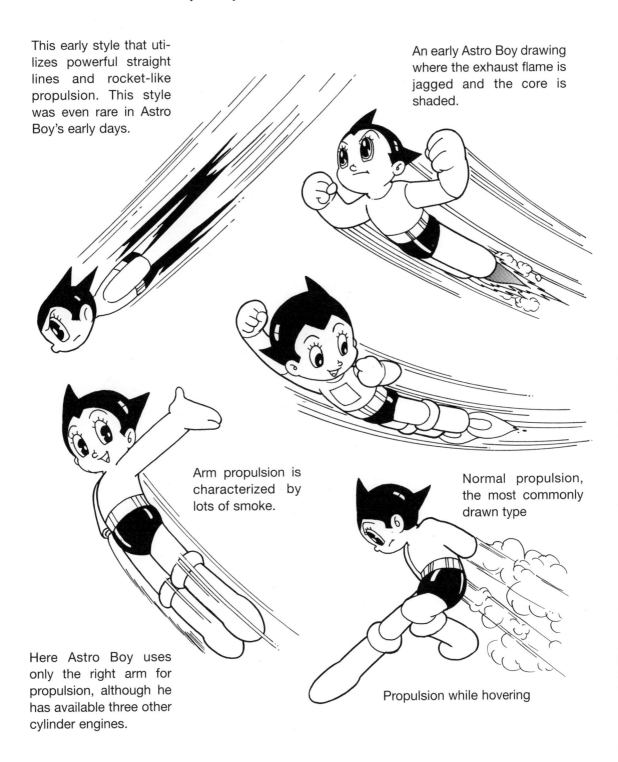

This early style that utilizes powerful straight lines and rocket-like propulsion. This style was even rare in Astro Boy's early days.

An early Astro Boy drawing where the exhaust flame is jagged and the core is shaded.

Arm propulsion is characterized by lots of smoke.

Normal propulsion, the most commonly drawn type

Here Astro Boy uses only the right arm for propulsion, although he has available three other cylinder engines.

Propulsion while hovering

Astro Boy's Unique Appeal

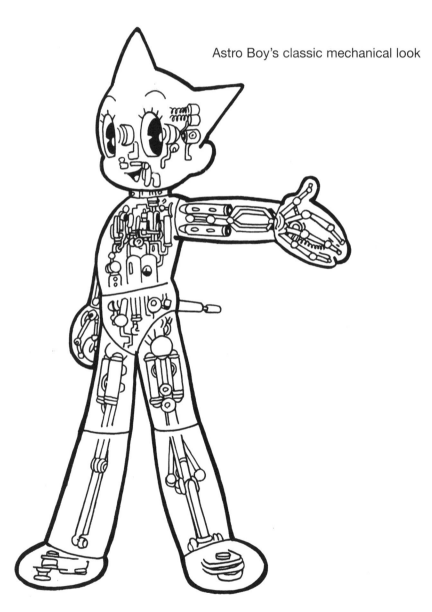

Astro Boy's classic mechanical look

Mechanics used in early Astro Boy drawings

Astro Boy's skeleton unveiled ●●●●●●●●●●●●●●● ●

The ears are one thousand times more powerful than human ears, and a sensor deep in the ear can hear ultrasonic sounds.

Artificial vocal cords allow him to speak 160 languages and communicate with aliens.

The eyes convert to searchlights in the dark and can even project stored images. They can also shed tears.

FP (flexible power) joints

The electronic brain can perform calculations, possesses a memory, and is capable of human emotions.

Energy capsule

FP joints

The nuclear-powered motor runs on deuterium and has an output of 100,000 horsepower.

Jet and rocket engine

Maximum speed in the atmosphere is Mach 5. On entering outer space, he switches to rocket power.

A telescopic machine gun capable of firing 1,000 rounds per minute is housed in the buttocks.

The feet retract to form a jet nozzle.

Facial mechanics—searchlight eyes ● ● ● ● ● ● ●

A cutaway of the face. The light beams can be made stronger or weaker by adjusting the energy level.

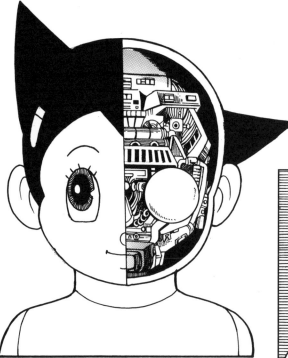

The searchlight eyes can be used to threaten foes.

At times the eyes project more powerful beams than a real searchlight

The light is extremely bright.

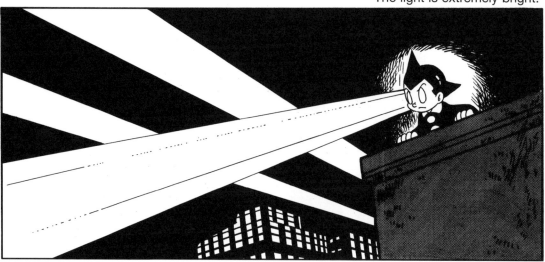

Spring-loaded head and neck ●●●●●●●●●●●●● ●

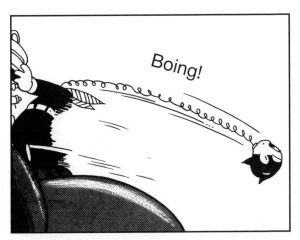

Boing!

With the early Astro Boy, the head sprang from the neck at the slightest shock. This was another gag. Because his head contained no vital parts, it could spring off without impairing his functions.

Astro Boy is manga-like science fiction. Its hero's ability to stretch his neck on a spring should be viewed comically.

When his head springs off, Astro Boy simply pops it back in place.

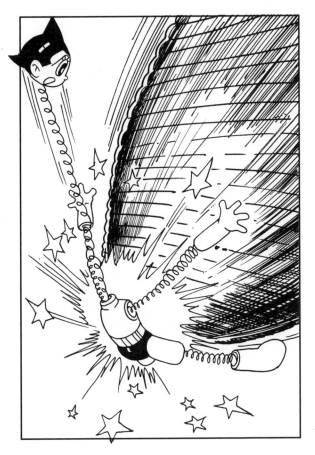

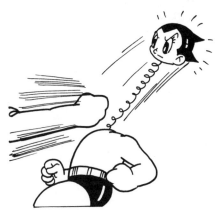

The neck stretches with the utmost ease.

The upper body and the chest hatch ••• Part 1

Meters on the inside of the hatch door indicate the energy level and how far Astro Boy can fly on the energy remaining.

Energy can be received from other robots through the chest hatch.

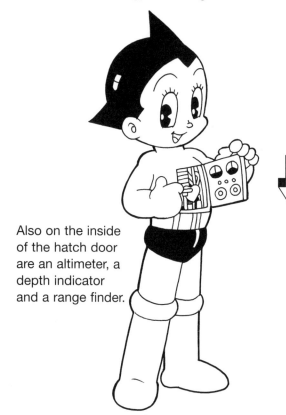

Also on the inside of the hatch door are an altimeter, a depth indicator and a range finder.

Sometimes the chest hatch opens to the left and sometimes to the right.

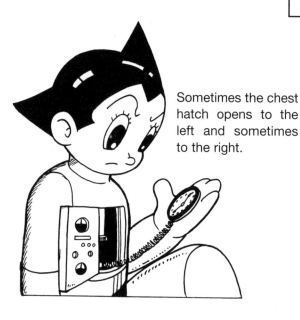

The chest hatch can also become a weapon.

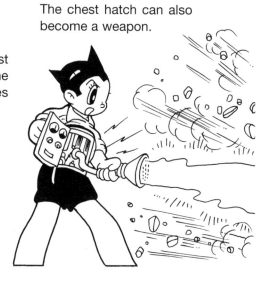

The upper body and the chest hatch ••• Part 2

The evolving interior of the hatch

A manga version of
the chest hatch.

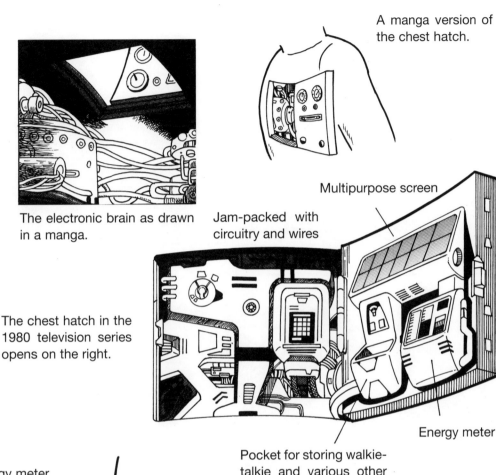

The electronic brain as drawn
in a manga.

Jam-packed with
circuitry and wires

Multipurpose screen

The chest hatch in the
1980 television series
opens on the right.

Energy meter

Pocket for storing walkie-
talkie and various other
equipment

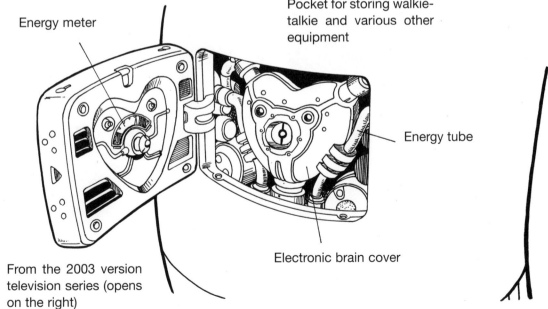

Energy meter

Energy tube

Electronic brain cover

From the 2003 version
television series (opens
on the right)

Refueling through the bottom ●●●●●●●●●●●●

In this early drawing Astro Boy pulls down his shorts to refuel.

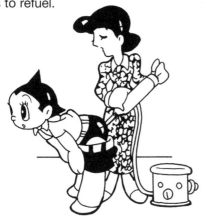

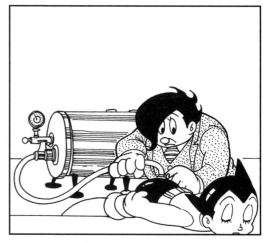

Astro Boy travels back in time and is refueled from an old-style tank by a friend.

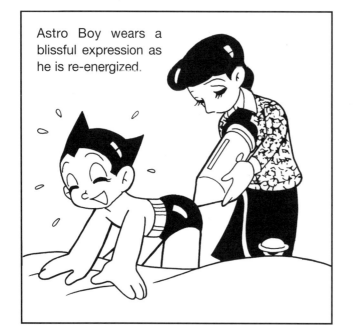

Astro Boy wears a blissful expression as he is re-energized.

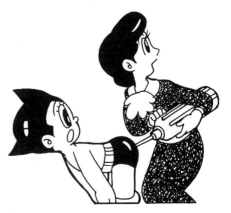

The energy tube varies depending on the period.

Energy tube

Astro Boy doesn't eat; he gets his energy from deuterium. The energy tube is inserted between the two barrels of the machine gun in his buttocks.

Machine-gun-equipped buttocks

The machine gun has changed slightly over the years.

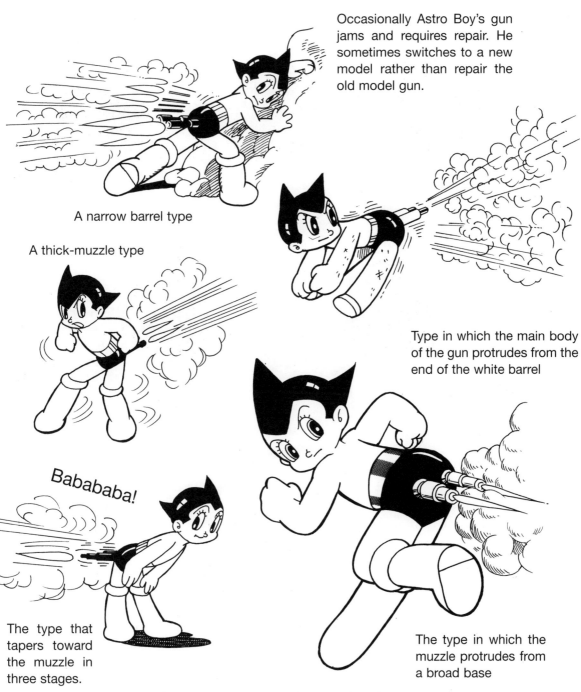

Occasionally Astro Boy's gun jams and requires repair. He sometimes switches to a new model rather than repair the old model gun.

A narrow barrel type

A thick-muzzle type

Type in which the main body of the gun protrudes from the end of the white barrel

Bababababa!

The type that tapers toward the muzzle in three stages.

The type in which the muzzle protrudes from a broad base

The shell cases are unique in that they turn to smoke upon contact with the air.

Holes appear.

Protective plates retract.

Gun barrels appear.

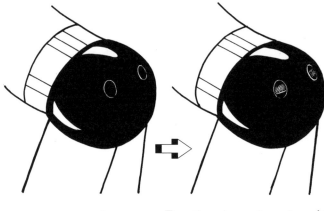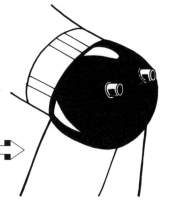

Two-tiered gun barrels appear.

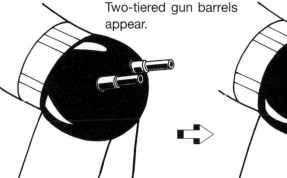

The barrels, fully extended, are ready for action. The rate of fire is 1,000 rounds per minute.

The unique shell cases turn to smoke upon contact with oxygen.

Astro Boy carries 500 (250 x 2) 5mm parabellum cartridges.

The sensors, responding to Astro Boy's will, cock the internally housed hammer.

The barrel extends and retracts (3 tiers) under hydraulic pressure.

The machine gun has three tiers and a length of 200 mm. The bullets are stored efficiently in the buttocks.

Firing mechanism
When Astro Boy aims at an enemy and readies the machine gun, sensors respond to his will and activate the firing mechanism.

The magazine holding the bullets is inside the abdomen.

Jet system of the legs ●●●●●●●●●●●●●●●●●●●●●●●●●● ●

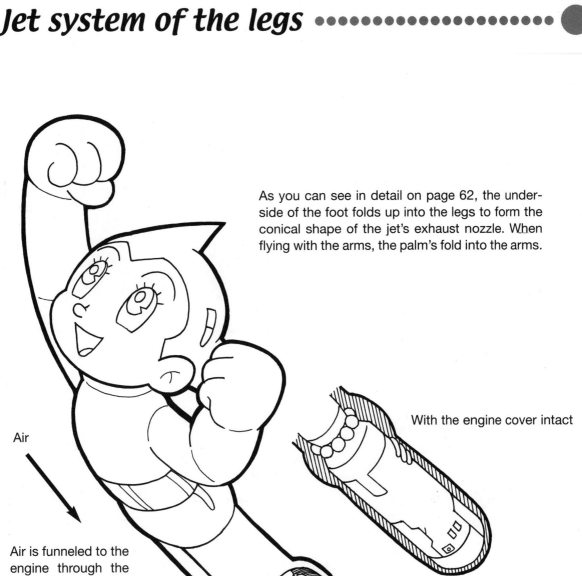

As you can see in detail on page 62, the underside of the foot folds up into the legs to form the conical shape of the jet's exhaust nozzle. When flying with the arms, the palm's fold into the arms.

Air

With the engine cover intact

Air is funneled to the engine through the mouth and a tiny aperture around the circumference of the neck.

The engine cover is enveloped in durable artificial skin.

Remove the engine cover and you see an air inlet and a jet fuel nozzle, among other things. When the atmosphere is thin or nonexistent, as in outer space or under the sea, the sensors switch to rocket power. An oxidizing agent stored inside the body helps burn the jet fuel that creates propulsion.

100,000 horsepower ●●●●●●●●●●●●●●●●●●●●●●● ●

Just how much is 100,000 horsepower? It must be an awful lot of power to enable Astro Boy to lift elephants, houses and ships.

Astro Boy lifting massive objects far larger than he.

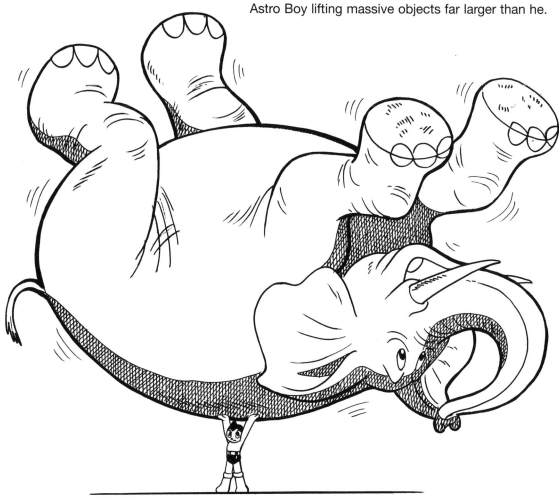

Broken Astro Boy •••••••••••••••••••••••••••••••• ●

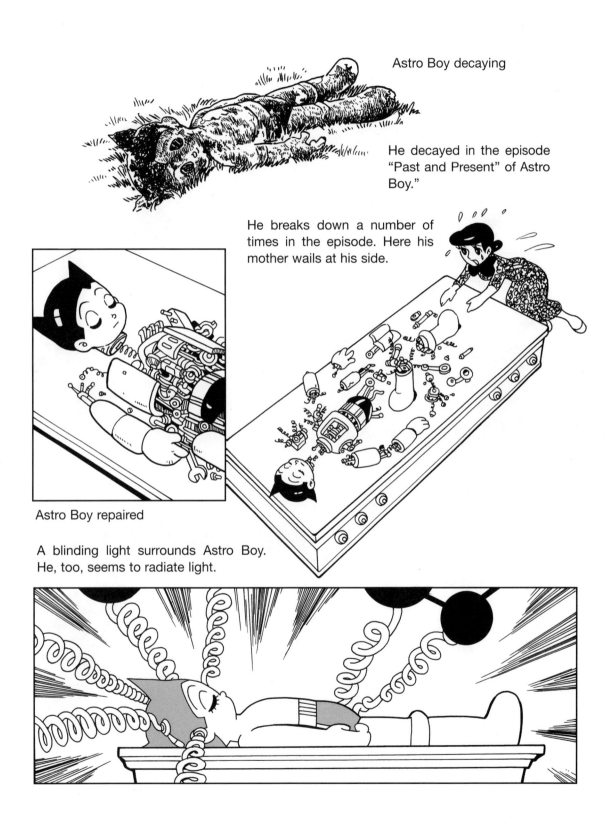

Astro Boy decaying

He decayed in the episode "Past and Present" of Astro Boy."

He breaks down a number of times in the episode. Here his mother wails at his side.

Astro Boy repaired

A blinding light surrounds Astro Boy. He, too, seems to radiate light.

Astro Boy's changing fashions •••••••• *Part* 1

Astro Boy was quite a dapper dresser.

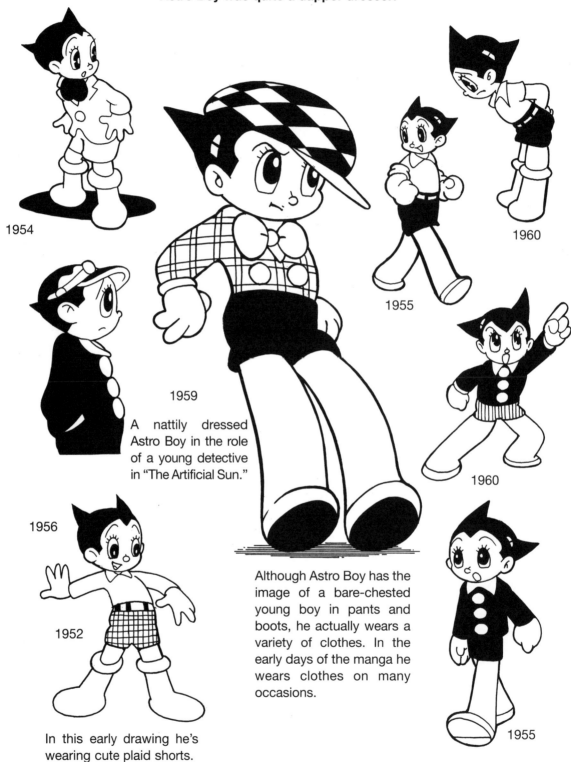

1954

1955

1960

1959

A nattily dressed Astro Boy in the role of a young detective in "The Artificial Sun."

1960

1956

1952

In this early drawing he's wearing cute plaid shorts.

Although Astro Boy has the image of a bare-chested young boy in pants and boots, he actually wears a variety of clothes. In the early days of the manga he wears clothes on many occasions.

1955

Astro Boy's changing fashions •••••••• Part 2

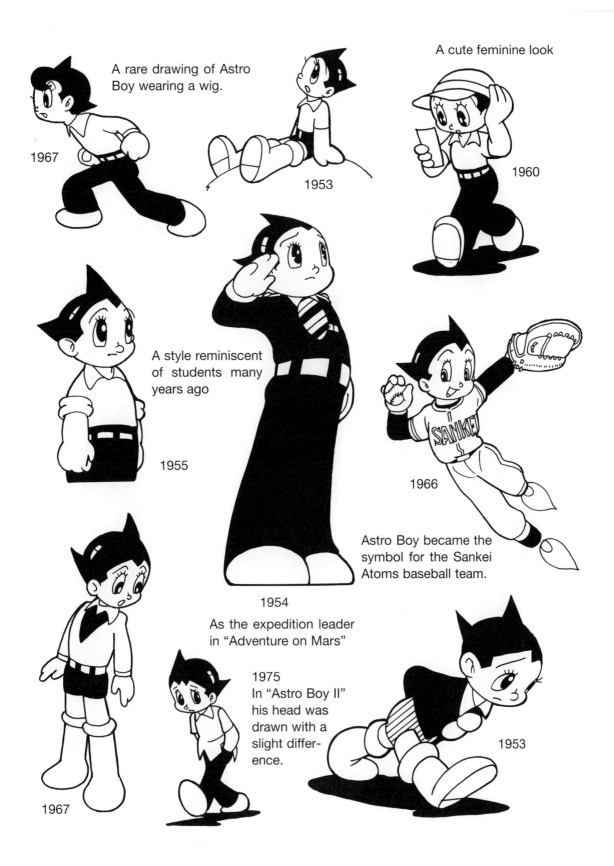

A rare drawing of Astro Boy wearing a wig.

1967

1953

A cute feminine look

1960

A style reminiscent of students many years ago

1955

1954

Astro Boy became the symbol for the Sankei Atoms baseball team.

1966

As the expedition leader in "Adventure on Mars"

1975
In "Astro Boy II" his head was drawn with a slight difference.

1967

1953

Astro Boy's changing fashions •••••••• Part 3

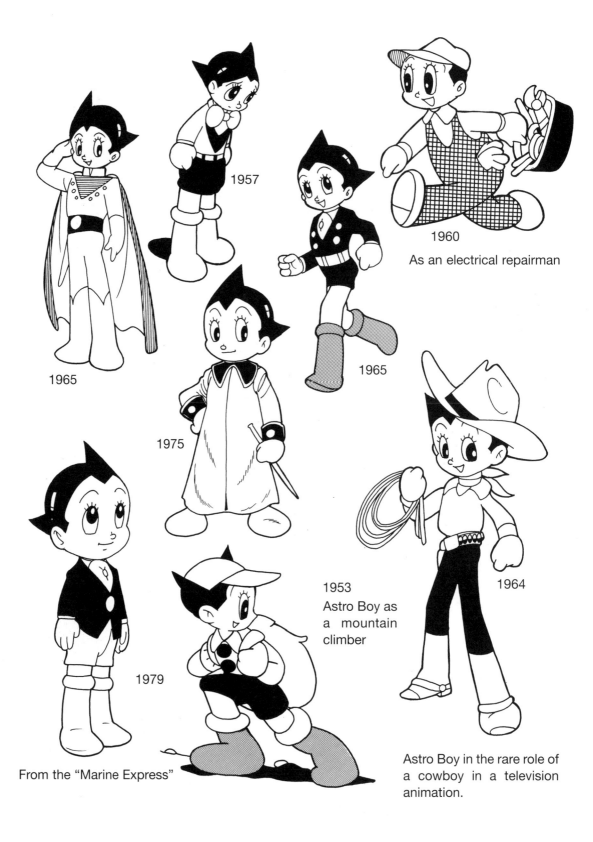

1957

1960
As an electrical repairman

1965

1965

1975

1953
Astro Boy as a mountain climber

1964

1979

From the "Marine Express"

Astro Boy in the rare role of a cowboy in a television animation.

Memorable supporting characters ••• Part 1

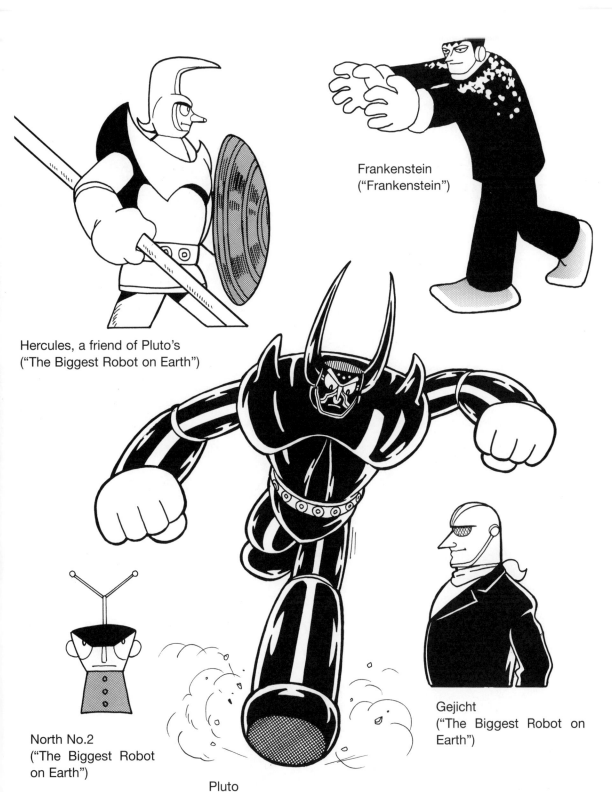

Frankenstein
("Frankenstein")

Hercules, a friend of Pluto's
("The Biggest Robot on Earth")

North No.2
("The Biggest Robot
on Earth")

Pluto
("The Biggest Robot on Earth")

Gejicht
("The Biggest Robot on
Earth")

Memorable supporting characters ••• Part 2

Robio

Robiet

("Robio and Robiet")

Space Leopard
("Space Leopard")

Dr. Hanabusa

Garon
("Astro Boy vs. Satan")

Transparent Giant
("Transparent Giant")

Memorable supporting characters ••• Part 3

Blue Bon
("The Blue Knight")

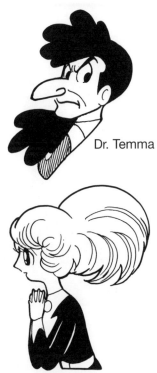

Dr. Temma

Maria, the supposed younger sister of Blue Bon ("The Blue Knight")

Dragon Robot and Satan ("Monster in the Robot Land")

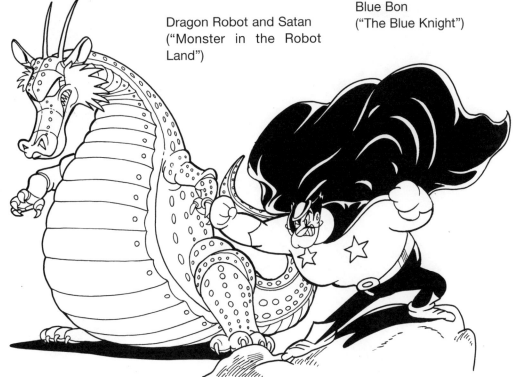

Memorable supporting characters ••• *Part* 4

Villains

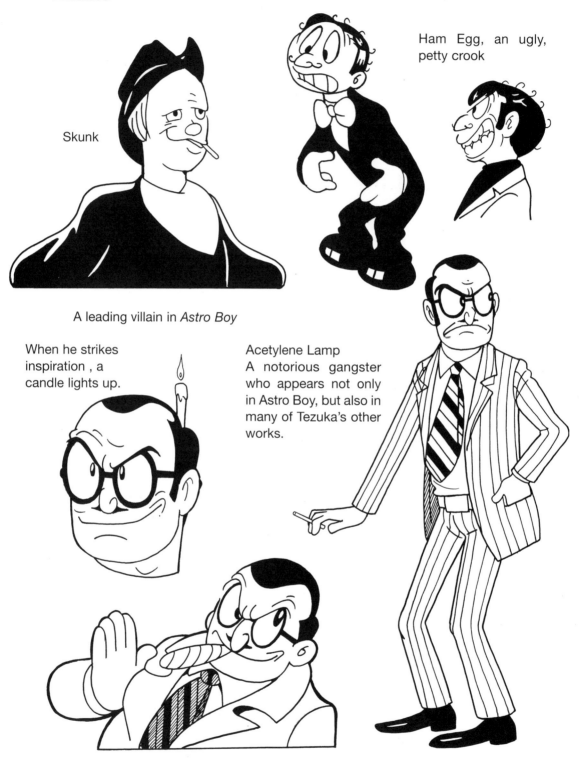

Skunk

A leading villain in *Astro Boy*

Ham Egg, an ugly, petty crook

When he strikes inspiration , a candle lights up.

Acetylene Lamp
A notorious gangster who appears not only in Astro Boy, but also in many of Tezuka's other works.

Astro Boy's mother and father ●●●●●●●●●●●●●

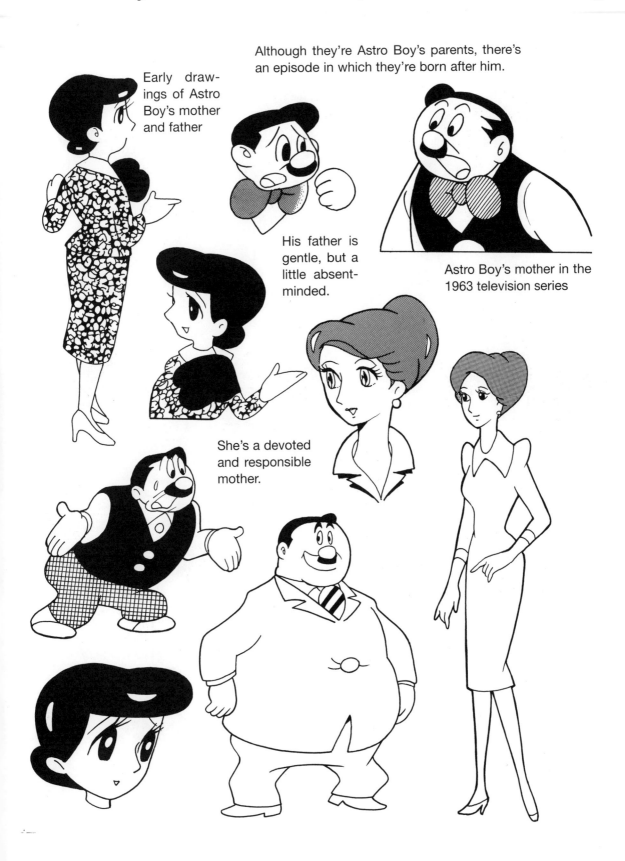

Although they're Astro Boy's parents, there's an episode in which they're born after him.

Early drawings of Astro Boy's mother and father

His father is gentle, but a little absentminded.

Astro Boy's mother in the 1963 television series

She's a devoted and responsible mother.

Uran and Cobalt

Uran is Astro Boy's younger sister. Tomboyish and mischievous, she cares strongly for her brother.

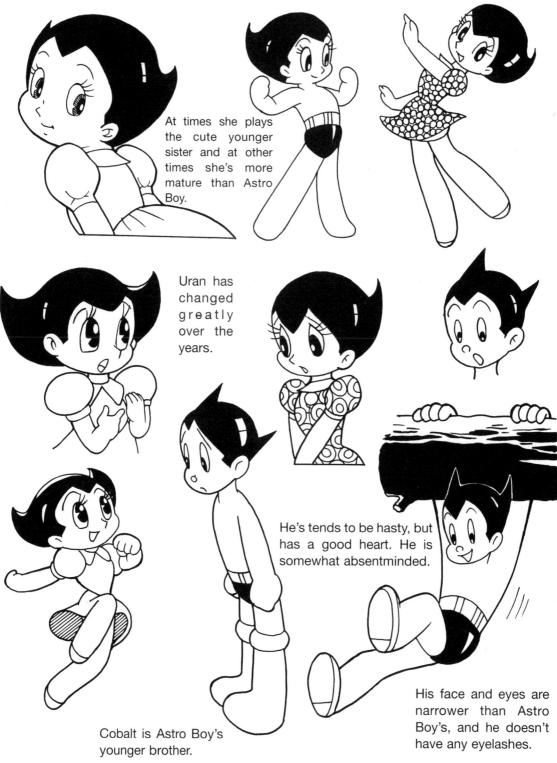

At times she plays the cute younger sister and at other times she's more mature than Astro Boy.

Uran has changed greatly over the years.

He's tends to be hasty, but has a good heart. He is somewhat absentminded.

Cobalt is Astro Boy's younger brother.

His face and eyes are narrower than Astro Boy's, and he doesn't have any eyelashes.

Memorable supporting characters around Astro Boy

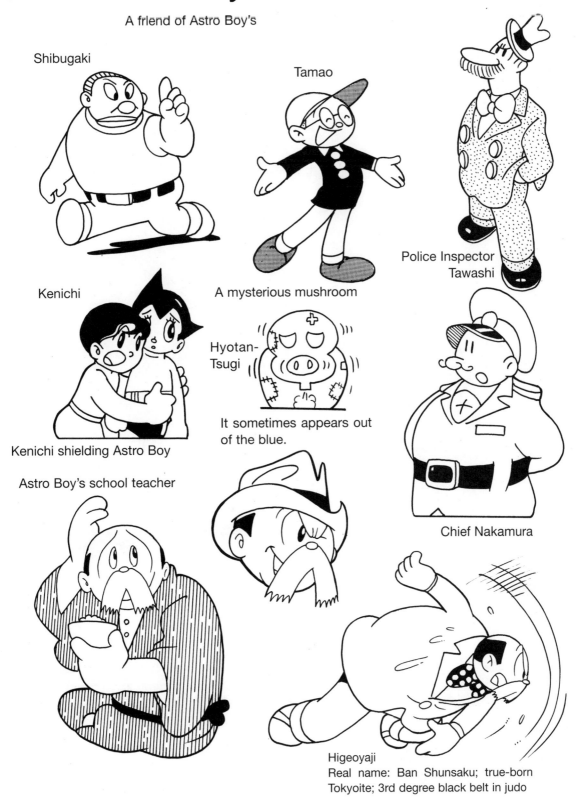

A friend of Astro Boy's

Shibugaki

Tamao

Police Inspector Tawashi

Kenichi

A mysterious mushroom

Kenichi shielding Astro Boy

Hyotan-Tsugi

It sometimes appears out of the blue.

Astro Boy's school teacher

Chief Nakamura

Higeoyaji
Real name: Ban Shunsaku; true-born Tokyoite; 3rd degree black belt in judo

Dr. Ochanomizu ●●●●●●●●●●●●●●●●●●●●●●●●●●●●●●

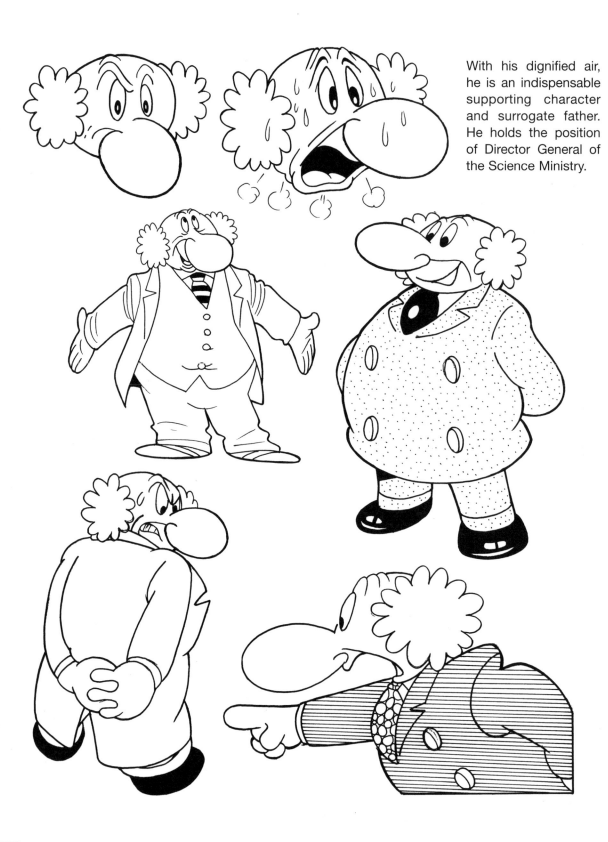

With his dignified air, he is an indispensable supporting character and surrogate father. He holds the position of Director General of the Science Ministry.

Osamu Tezuka (1928-1989), Japan's greatest manga artist

Born in Toyonaka City, Osaka, in 1928, and brought up in Takarazuka, Osamu Tezuka graduated from Osaka University with a medical degree and obtained a doctorate in medicine in 1961. From childhood he drew manga and was familiar with Walt Disney animation. Through his mother's influence, he acquired an appreciation for the Takarazuka Revue. Around 1939 he began assiduously collecting insects, amassing a collection of approximately 3,000. After reading Hirayama Shujiro's book *One Thousand Colorful Insects Illustrated* and learning of a beetle called "osamushi," he decided to add the Chinese character for insect to his name, thus creating the pen name Osamu Tezuka. In junior high school he drew butterflies and beetles that far surpassed those of his peers in accuracy and brilliance. An interest in astronomy led him to create from the bladder of a ball, a planetarium, which he shared with friends. All these varied interests were the base of his materials which Osamu Tezuka's Astro Boy and other masterworks were built upon.

In 1946, aged 18, Tezuka made his professional debut with "Diary of Ma-chan" (Mainichi School Children's Newspaper). This was followed by *Astro Boy*, one of his most celebrated works. *Astro Boy* ran as a series for 18 years beginning in 1951; it was also animated three times for television, in 1963–1966, 1980–1981 and 2003–2004.

Osamu Tezuka passed away in 1989, leaving a legacy 700 manga works totaling 150,000 pages. He had also created 60 animated television shows, movies, and experimental works. Tezuka's legacy will continue to influence cartoonists, film directors and artists for years to come.

Osamu Tezuka's manga and animated works •••

Manga
"Diary of Ma-chan" (debut work), "Lost World," "New Treasure Island," "The Mysterious Underground Man," "Stream Line Case," "Metropolis," "Detective Boy," "Rock Home," "FAUST," "Jungle Emperor Leo," "Manga Classroom," "Next World," "The Road to Utopian Lurue," "Saboten-kun," "Age of Adventure," "The Adventure of Rock," "I'm Songoku," "Astro Boy," "Crime and Punishment," "Ribbon Knight," "Princess Knight," "Lemon Kid," "Queen Nasubi," "Chief Detective Kenichi," "Yokko-chan Had Camel," "Phoenix," "Lion Books Series," "Manga Astronomy," "The Film Is Alive," "The Devil Garon," "Dr Thrill," "I am Sarutobi!," "Captain OZMA," "The Ant and The Giant," "Big X, Story of Animals," "Ambassador Magma," "Amazing Three (W3)," "Vampire," "Dororo," "Norman," "Under the Air Series," "Blue Triton (Triton of the Sea)," "Human Metamorphosis," "ZEPHYRUS," "Birdman Anthology," "Insect Collector," "The Lips of Salome," "Shumari," "AYAKO," "Black Jack," "BARUBORA," "The Three-eyed One," "Peace Concert," "Unico," "Mako," "Rumi and Chii," "The Thief Inoue Akikazu," "Tezuka's Ancestor," "Dr. Ryoan," "Don Dracula," "The Stories of Three Adolfs," "Ludwig B, Gringo," "Neo Faust," etc.

Animation
Tales of the Street Corner, Astro Boy, Jungle Emperor Leo, Pictures at an Exhibition, Ribbon Knight, A Thousand and One Nights, Dororo, Cleopatra, The Kindly Lion, Marvelous Melmo, Bander Book, PHOENIX 2772, Baggy, Jumping, Broken Down Film, Legend of the Forest, In the Beginning, etc.

Awards
Manga: Shogakukan Manga Award, Kodansha Manga Award, Bunshun Manga Award etc.
Animation: Art Festival Promotion Award, Ofuji Noburo Award, Blue Ribbon Educational and Cultural Film Award, Grand Prize at the Zagreb International Animation Festival, Grand Prize at the Hiroshima International Animation Film Festival, posthumous conferral of the "Order of the Sacred Treasure" etc.

About the author ●●●●●●●●●●●●●●●●●●●●●●●●●●●●● ●

Kobayashi Junji, author

1948 Born in Tokyo
1966 Enters Mushi Production as an animator
1978 Establishes Tezuka Productions' Animation Division

Animated works
Astro Boy (black-and-white version), *Ribbon Knight, A Thousand and One Nights, Cleopatra, PHOENIX 2772, Jumping, Broken Down Film, Legend of the Forest, In the Beginning, I'm Songoku* (original), *Jungle Emperor Leo, Adachi-gahara, Legend of the Forest 2002*(drawings director), etc.
Commercials for ASAHI PENTAX, Kirin Beer, Parco Gourmet etc.

Illustrations, picture books
Urban Insect Magazine, Fabre Insect Record, Journey Into the Wild, Transformation—Maturation and Metamorphosis, How to Photograph Railways, etc.

Books, Commentary
Tezuka Osamu's Insect Guidebook, Tezuka Osamu Museum, Tezuka Osamu's Insect Kingdom, Tezuka Osamu's Animal Museum, etc.

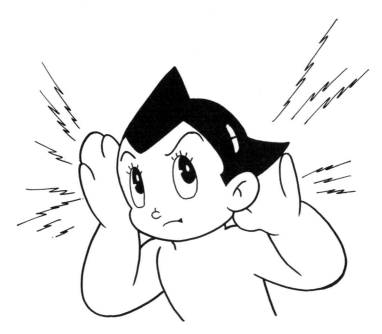

Astro Boy's ears are one thousand times more sensitive than human ears.

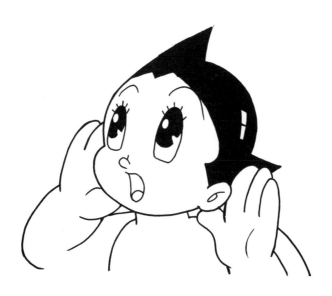

Let's draw Astro Boy one last time •••••

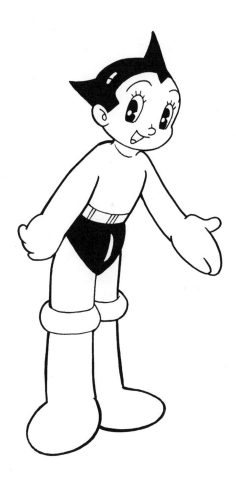

First draw a moon-shaped tray.

Sketch the ears, then the lower jaw.

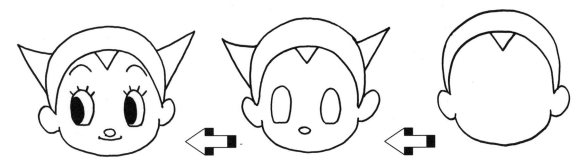

Draw the eyebrows and eyelashes. Now he is complete.

Draw big round eyes.

Draw another semi-circle, then a small triangle.

More!!! Let's Draw MANGA 漫画

Let's Draw Manga - Transforming Robots
By: Yasuhiro Nitta: PLEX
ISBN :1-56970-991-2
SRP: $19.95
Softcover w/ Dustjacket, 7 1/8" x 10 1/8"
Approx: 128 pages in B&W
English text, Digital Manga Publishing (DMP)
NORTH AMERICAN TERRITORY

Transforming Robots has been staple in anyone's life when watching cartoons, reading comic books or even playing video games. The way they magically transform and the complexity of their designs have captured the imagination of viewers for years.

People interested in drawing these transforming robots will find that this book is filled with all the useful and necessary information that one requires. Artists will learn from the pros about basic design history and cube transformations. Inside you will also find chapters dedicated to specific types of transforming robots. Like Sports Cars, Semi-trailers, Bulldozers, Tanks, Jet fighters, Dinosaurs and more. This book covers it all with lots of illustrations and easy to understand step by step descriptions. Step back and prepare to transform your drawings!

Let's Draw Manga - Ninja & Samurai
By: Hidefumi Okuma
ISBN : 1-56970-990-4
SRP: $19.95
Softcover w/ Dustjacket, 7 1/8" x 10 1/8"
Approx: 118 pages in B&W
English text, Digital Manga Publishing (DMP)
NORTH AMERICAN TERRITORY

Fueled by classic hits such as the animated film, *Ninja Scroll* and the best-selling manga, *Lone Wolf and Cub*, the Western audience's fascination with ninjas & samurai has reached peak levels over the last few years. In this book, the artist will learn to draw about the daily life and tools of the legendary samurai and their most menacing foes, the ninja along with a wide variety of characters including feudal lords, the Kunoichi "female ninja", the mendicant zen priests, merchants, and much, much more. By providing the readers with a close and detailed look at their appearances, facial expressions, clothing and weaponry, artists will gain the knowledge and ability to create great looking comics of this genre. This book will serve as a one-of-a-kind reference for any manga artist aspiring to create his or her samurai and ninja action series.

Let's Draw Manga - Sexy Gals
By: Heisuke Shimohara
ISBN : 1-56970-989-0
SRP: $19.95
Softcover w/ Dustjacket, 7 1/8" x 10 1/8"
Approx: 118 pages in B&W
English text, Digital Manga Publishing (DMP)
NORTH AMERICAN TERRITORY

Sexy and appealing *Let's Draw Manga- Sexy Gals*, helps to deliver that romantic element to a person's work that may be missing. Drawing beautiful women and men in seductive poses can be one of the trickiest and most problematic for an artist to depict sincerely. Long flowing hair, body proportions, poses and clothing that hang by a thread are just some of the attributes that will help to lend to the physical attractiveness and prowl-ness of your drawings. Mini-skirts and open shirts with a touch of soft and heavy petting. *Let's draw Manga- Sexy Gals* is a fun and flirtatious book with a provocative look at suggestive comics.